T0377527

BALL ROOM

A HISTORY, A MOVEMENT, A CELEBRATION

BALL ROOM

MICHAEL ROBERSON
WITH MIKELLE STREET

RUNNING PRESS
PHILADELPHIA

CONTENTS

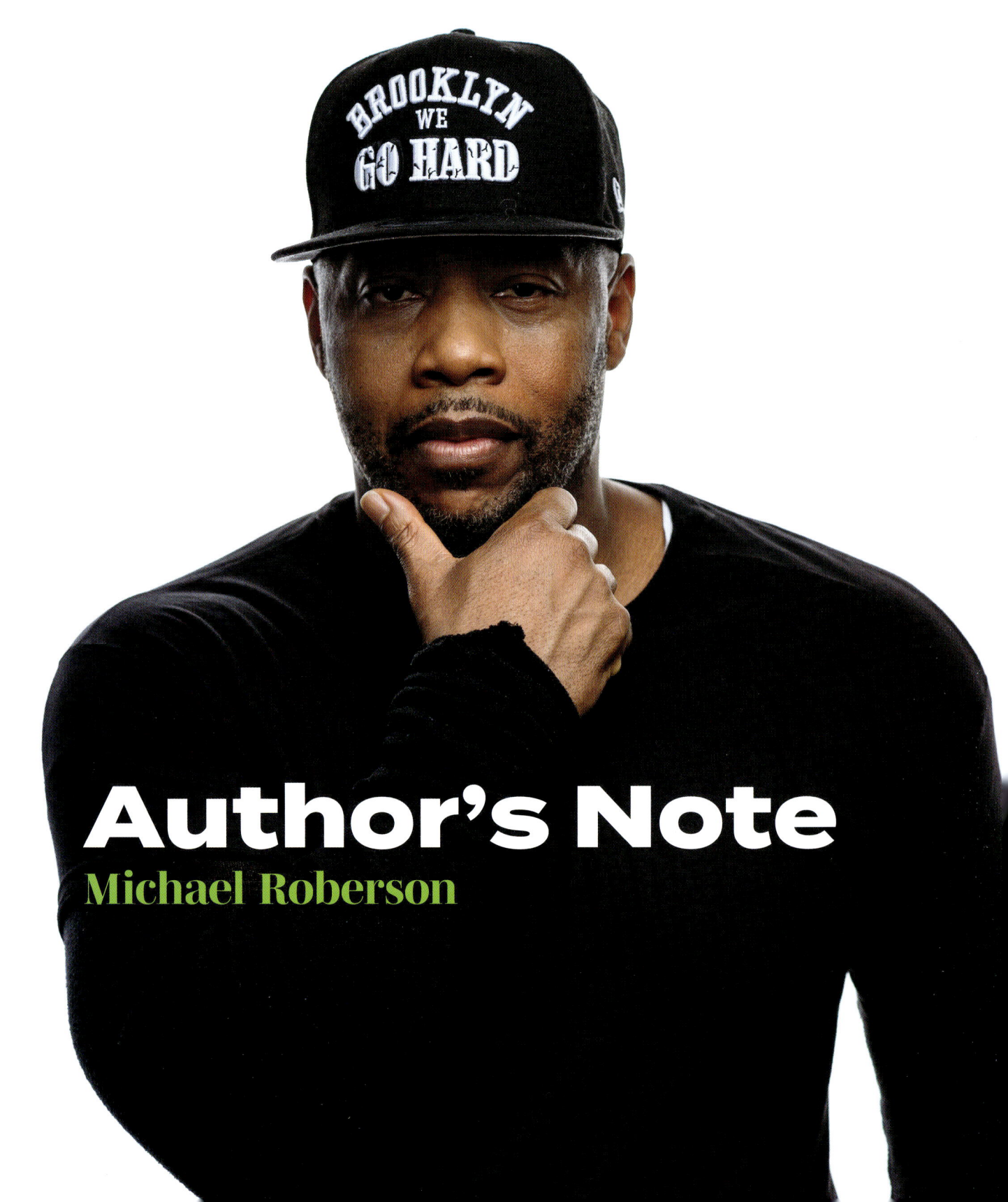

Author's Note

Michael Roberson

As I sit here in my apartment in the Bedford-Stuyvesant neighborhood of Brooklyn—on a tree- and lamppost-lined block of brownstones—I am in deep reflection. I began writing this book in 2023, when we were still reeling from the COVID-19 pandemic, the war in Ukraine, George Floyd's murder, the January 6 insurrection, the overturning of *Roe v. Wade,* the ongoing war and conflict in the Middle East, and the consequences of ecological neglect and climate change that daily challenge people worldwide. Even more a sign of the challenging times the world finds itself in, as I write these words, is the increasing number of mass shootings that continue to devastate the nation. And for me, on a deep personal and visceral level, the number of Black and Brown trans women being brutalized and murdered has become so staggering that I fight not to become numb and discouraged about notions of freedom and joy, just as I fight not to become desensitized to these challenging times.

All these things leave indelible marks of pain and misery on the individual and collective spirits of humanity. I, we, all could use a counter-memory, one that uplifts the spirit, that holds joy in its grasp, that puts a smile across the face. Memory can be a space for the utopian social imagination, but it can be more than that, too. Memory, as the great author Toni Morrison wrote, "is a form of willed creation. It is not an effort to find out the way it really was—that is research." And so, my thoughts turn to the legacy of Ballroom, a community and phenomenon created in a bleak landscape and built with intention, love, and respect.

As I write these words, I am also in deep gratitude for my life, my journey that brought me to this moment. You see, I was born through the womb of an unapologetic Black woman named Mary Elizabeth, in the inner city of Camden, New Jersey, across the Delaware River from the City of Brotherly Love, Philadelphia. My mother was, cosmologically, my God and Goddess at the same time. And so were her sister-friends and my four sisters, my two older nieces, my aunts on my father's side of the family, and all my Black women teachers. They all represented, for me, as a young Black gay boy growing up in the inner city, magnificent Gods and Goddesses, exactly the inspiration I needed to get me through life.

In retrospect, it makes perfect sense that I was inspired to enter Ballroom when I became captivated by the absolutely stunning Black/Latinx trans women who are the Goddesses of the community. The women of this culture showed me what was possible, what kinds of freedom you could manifest when you embrace the social imagination to create a way out of no way—when nothing in your surroundings, when nothing in *life*, points to the fact that living and expressing yourself freely as an LGBTQ+ person could ever be possible.

I saw Jennie Livingston's 1990 film *Paris Is Burning*, a documentary that chronicled the lives of Black/Latinx LGBTQ+ folks in New York City, and I was stunned. I was in awe. I was amazed and encouraged all at once. On my television screen entered two beauties: the late greats Venus Xtravaganza and Octavia St. Laurent. Both were sleek, modelesque, stunningly beautiful, and articulate in a language that I did not necessarily understand but that spoke directly to my soul, to my spirit, to my sense of wonder. Both Venus and Octavia would become pioneers of and draft the blueprint for the Ballroom community, and they were especially important trailblazers for the legions of trans women today. Their long-standing legacy and impact will be felt for generations to come.

I entered the Ballroom scene a couple of years later, in late 1994/early 1995, as a member and participant in Philadelphia. There, I encountered three trans women who became my holy trinity: Miss Renee Karan, the Mother of Philadelphia Ballroom, who was historically and affectionately bestowed that title because of her rich legacy there; Miss Taffy Jadu, the Godmother of Philadelphia Ballroom, given that title by the local community because in 1988, before Philadelphia's scene was established in 1989, she was the first trans woman from Philadelphia to create a House and to venture to New York to walk balls; and Miss Kelly Harper, whose body politics and aesthetics captured the imagination of what Philadelphia Ballroom trans women would become. These pioneering Ballroom Icons—those on whose shoulders I and a multitude of others stand, who paved the way for a community out of no way—awed me.

MY HOUSES

When I look back, I've been blessed to have been a part of eight Houses, four of which I founded and cocreated:

1. Romeo Gigli (member)
2. Ebony (member)
3. Manolo Blahnik (cofounder, alongside Jay and Preston)
4. Maasai (cofounder/the Overall Father, alongside cofounders Jon Gabriel, Dominique Jackson/the Overall Mother, and Zoliy King)
5. Miyake-Mugler (NY Father)
6. Comme des Garcons (cofounder and NY Father, alongside cofounders Shannon, Whitney/the Overall Father, and Julian)
7. Milan (member)
8. Maison Margiela (Overseer, alongside cofounders Vinny/the Overall Father, Tre, Tempress/Queen Mother, and Terrance Smylez Willis/Atlanta Father)

While we were in the House of Milan, my kinship son Tre and I headed to Miami, Florida, in 2015 for Tone Milan's ball.

The Royal Haus of Maison Margiela celebrated the 10th anniversary of the Ballroom Throwbacks Ball at the Knockdown Center in Queens, New York. The author (in the black hat, second from the right) and his kinship son Vinny (in white fur coat) were cofounders along with Terrance Smylez Willis (in black fur coat), Chastity Moore aka Tempress (in yellow), and the author's kinship son Tre.

Although I was out and self-defined as a Black gay man and part of the Black LGBTQ+ community years before they were, I followed my kinship sons (some might call them my chosen sons) in Ballroom. I first became a member of the House of Romeo Gigli, created by my good friend and fellow New Jerseyan, the late great Otis Romeo Gigli. I left the House of Romeo Gigli in late 1996 to become a member of the House of Ebony, following my kinship son Jay and under the tutelage of one of Philadelphia's powerful emerging young leaders in the Ballroom community, Mann, who was, at the time, the Father of the Philadelphia chapter of the House of Ebony. I competed at balls in an aesthetic category called Body, based on physique and a certain showmanship, as well as Realness with a Twist (a hybrid category combining gender passing and vogue performance).

I moved to New York City in 1999, leaving the House of Ebony. At about the same time, my interest began to shift; instead of wanting to compete, I believed my purpose in the Ballroom community was in leadership development and community organizing.

As testimony to my shift in purpose, I created a health, wellness, and HIV prevention/testing ball called the POCC (People of Color in Crisis) Ball, which was the second-largest annual ball at that time and free to the public. I also created a community organizing initiative called the Federation of Ballroom Houses, a New York City–based coalition of Ballroom leaders whose aim was to address the intersectional disparities confronting the community. These decisions changed the trajectory of my Ballroom career.

◊◊◊

Today, as the very fabric of our democracy is being tested, the legacy and importance of the Ballroom community matters even more. In July 2023, a young Black gay man named O'Shae Sibley, an emerging leader in the Ballroom community, was voguing shirtless to a Beyoncé song when he was stabbed to death by a seventeen-year-old teenager at a gas station in Brooklyn. An early justification given was that O'Shae's self-expression was an affront to his attacker's religious beliefs.

Mourners created a memorial to O'Shae Sibley at the gas station in Brooklyn, New York, where he was murdered.

In June 2024, ArtsWestchester hosted Ballroom Has Something to Say: An Ode to Black Gay/Queer Men, *a performance production that included vogue dance, oratory, poetry, and song.*

The response to the tragedy from the Ballroom community was astounding. In massive numbers, people marched and organized a civil disobedience protest at the exact site of O'Shae's murder. The protest was filled with speeches, communal chants, and political resistance through the art of vogue. Multiple cities, including Miami, Los Angeles, and Toronto, collaborated with the local Brooklyn community to hold events at the same time. The moment, to me, weaves together so many themes about Ballroom: how the LGBTQ+ community is on intimate terms with death, how we show up and organize to fight for one another, how a global community can rally together to recognize the value of an individual and their right to express joy, and our ability to emphasize love and support in the face of tragedy.

I am so very proud and grateful to be part of the Ballroom legacy. It is a legacy that has influenced the world for more than a century. It is also a legacy that comes out of Black people's struggle for freedom, whose politics is grounded in an authority that claims over and over again that we have a right to live. The legacy also matters because it is grounded in a theology of mattering, of what I call "somebodiness." Even when we have been told relentlessly that we are not anybody, we matter.

As a self-determined and self-defined Black gay man who has been a member of the Ballroom community for almost thirty years; a creator of Houses; an inductee into the Ballroom Hall of Fame, and one called leader, organizer, Father, Icon, telling the story of the legacy of Ballroom is a *calling* of my soul. It is the work that my soul must do. And so I begin.

Introduction

"Black women are the mules of the earth," Nanny tells Janie Crawford in the 1937 book *Their Eyes Were Watching God*, penned by African American Harlem Renaissance writer and poet Zora Neale Hurston. Given the times in which Hurston wrote this, it's safe to assume that she was speaking of Black cisgender women. But let's take some literary license and include Black trans women in Hurston's analysis.

In a contemporary context, transgender, lesbian, bisexual, and gay Black men and women must overcome complex challenges to establish and secure welcoming and nourishing communities. While we may already be connected to multiple social groups, our membership in these groups is almost always conditional and tenuous—our Black community members may not accept our sexuality or gender, while others may not accept our Blackness. Constant marginalization sustains the community's burdens of, for example, stigma, violence, housing insecurity, and HIV infection rates, which are estimated to be among the highest of any community in the United States.

One response to marginalization has been the formation of self-sustaining social networks and cultural groups such as the House/Ballroom scene, a Black/Latinx LGBTQ+ artistic collective and intentional kinship system that involves consciously choosing one's family members and thereby entering into a new chosen family—and by extension, being connected to untold numbers of like-minded folks.

The roots of Ballroom stem from the Harlem Renaissance, and it has grown over the past fifty years and ultimately surpassed both the emblematic film *Paris Is Burning* and the music video "Vogue" by Madonna.

This book explores the history of the House/Ballroom community beyond what has been traditionally explored—through an interdisciplinary lens, through a lens that is both theological and political—to think about House/Ballroom as a Black freedom movement and an artistic collective, a spiritual formation, and in the words of Dr. Martin Luther King Jr., a "beloved community" grounded in radical inclusion, confronting and responding to race, class, sexuality, gender oppression, and much, much more. We

examine the community's ability to use the art of performance—such as vogue, the community's premier dance form—as a hermeneutics of the body, a way to contextualize the conditions of pain, joy, life, and death, as well as an ability to engage in truth-telling and transmute pain into power.

Most importantly, this book will illuminate the community's unique strategy of making a way out of no way, especially because it is a community that has been and continues to be on intimate terms with notions of death, but has been able to adapt in the face of them to create life and freedom—not only in Harlem, where House/Ballroom began, but across the globe.

The book excavates a history not widely known and needing to be told. It is guided by two powerful principles, both traditions of freedom-making. The first was articulated by Dr. Cornel West in his 2014 book *Black Prophetic Fire*. Speaking to NPR about his book, West said that "a prophetic person tells the truth, exposes lies, bears witness and then, usually, is pushed to the margins or shot dead. . . . Lo and behold, here goes a great tradition of a people who have been hated and despised, but still loved—a people who were deceived, but still wanted to be honest as Du Bois, as Douglass, as Ida B. Wells, as Ella Baker, as Martin and Malcolm. Not perfect, but exemplary figures of integrity, honesty, and decency; and therefore, an example for all of us, regardless of color, sexual orientation or nation."

The second principle, revolutionary hope, was articulated by Angela Davis in a 2017 talk she gave at the Centre de Cultura Contemporània de Barcelona. She said, "As long as I have identified as a feminist it has been clear to me that any feminism that privileges those who already have privilege is bound to be irrelevant to poor women, working-class women, women of color, trans women, trans women of color. . . . Revolutionary hope resides precisely among those women who have been abandoned by history and who are now standing up and making their demands heard. . . .

"I'm referring to the women at the very bottom: poor women, Black women, Muslim women, Indigenous women, queer women, trans women. As a matter of fact, trans women of color have been most despised, most subject to state violence, most subject to

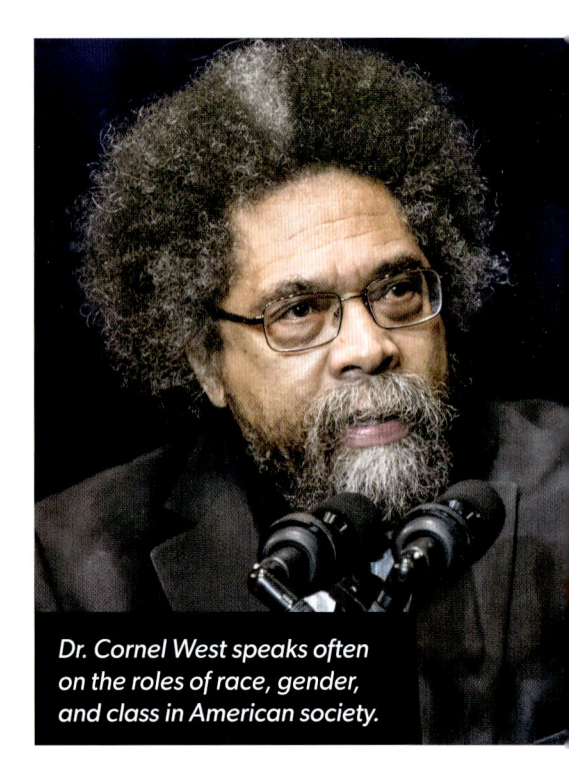

Dr. Cornel West speaks often on the roles of race, gender, and class in American society.

individual violence. We can say that when people who have suffered in that way, when they begin to rise, the whole world will rise with them."

The combined ideas of black prophetic fire and revolutionary hope reflect the desire in this book to tell a history of a people that has never been told, with a hindsight that digs to uncover its truth, with an insight that interrogates to investigate its truth, and with a foresight that sees beyond the veil of oppression to foreshadow its lasting truth. Finally, this book concludes by looking ahead, examining what the future holds for Ballroom and what its relevance is.

Ultimately, it asserts that Ballroom has something to say about what it means to be human, and to struggle for freedom in the face of catastrophe.

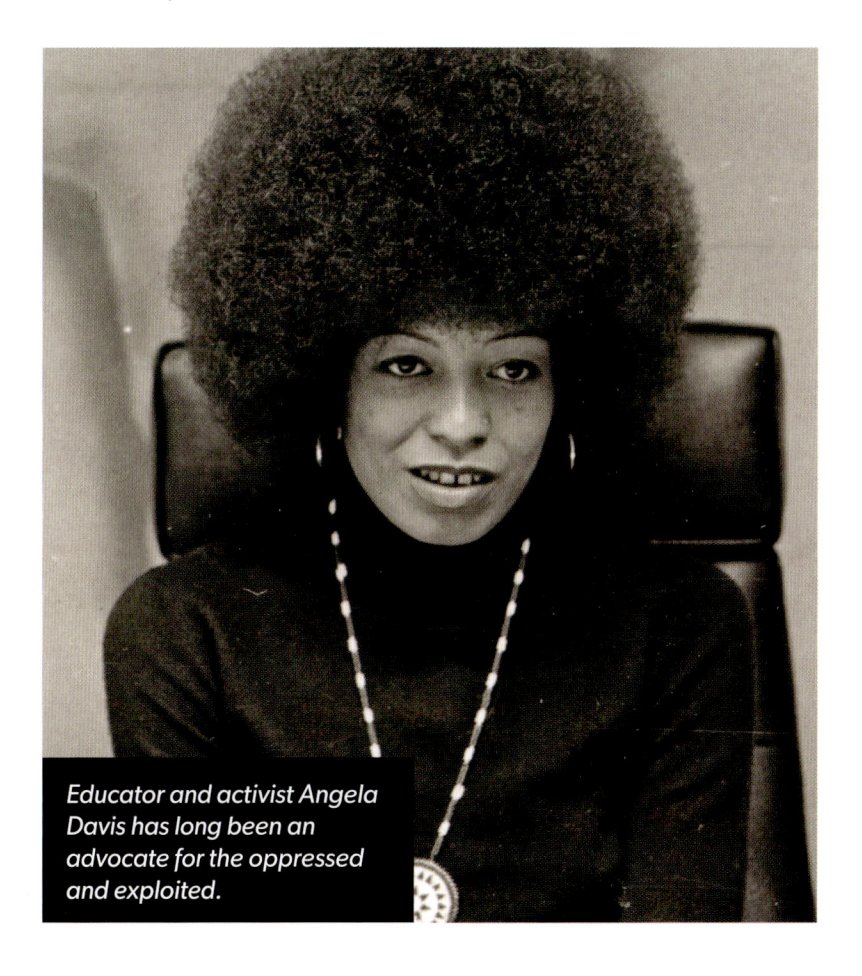

Educator and activist Angela Davis has long been an advocate for the oppressed and exploited.

Dee Dee Lanvin, Overall Mother of the House of Xclusive Lanvin, entered in a gilded birdcage at the House of Miyake-Mugler's 30th anniversary Porcelain Ball in New York City in 2019. She won the Face category and shared the $10,000 grand prize with her House daughter Erykah.

THE SIX TENETS OF BALLROOM

The mothers of womanist theology, Dr. Jacquelyn Grant, Dr. Delores Williams, and Dr. Katie Cannon, came together in the early 1980s to develop theological hermeneutics and ethics created for and by Black women. These brave and audacious women were all students at Union Theological Seminary in New York City (although not all in the same years), and all were interested in examining how both Black liberation theology (first articulated in James Cone's 1969 book *Black Theology and Black Power*) and feminist theology (pioneered in the 1970s by white Christian women) failed Black women in their critiques of, respectively, white supremacy and patriarchy.

These three scholars instead embraced *womanism* (a term first used by Pulitzer Prize–winning author Alice Walker) as the basis for a theological ethics for and by Black women. In her 1971 short story "Coming Apart," Walker defined womanism as "embracing the courage, audacity, and self-assured demeanor of Black women, alongside their love for other women, themselves, and all of humanity." In her 1983 book *In Search of Our Mothers' Gardens*, Walker further stated that a womanist is "a woman who loves other women, sexually and/or nonsexually. Appreciates and prefers women's culture, women's emotional flexibility . . . and women's strength. . . . Committed to survival and wholeness of entire people, male and female. Not a separatist, except periodically, for health. . . . Loves music. Loves dance. Loves the moon. Loves the Spirit. . . . Loves struggle. Loves the

Alice Walker's definition of womanism *influenced womanist theology, which in turn influenced the lens through which she wrote* The Color Purple.

Folk. Loves herself. Regardless. Womanist is to feminist as purple is to lavender."

Although Walker self-defines as a queer woman who is also Buddhist, Williams, Cannon, and Grant used this definition of womanism as a theological Christian framework.

I was first introduced to womanism during my second semester of my second year in graduate school at Union Theological Seminary in a class called Womanist Ethics, taught by the Reverend Dr. Eboni Marshall Turman. There, I found a language that codified the deepest tensions that I and other Black gay men were wrestling with—between divinity and abomination, between radical Blackness and black homophobia, between notions of freedom/justice and oppression/brutalization. My education in womanist ethics also provided me with a template to expand the work I believed my soul was created to do: the work with and for Ballroom.

In her 2006 book *Mining the Motherlode: Methods in Womanist Ethics*, Stacey M. Floyd-Thomas, womanist scholar and the E. Rhodes and Leona B. Carpenter Professor of Ethics and Society at Vanderbilt University, used Alice Walker's foundational definition of womanism as a dialogue partner, guide, and template to construct the tenets of womanism within the larger discipline of Christian ethics.

In my view, these tenets provide a fruitful basis to think about the work of Ballroom, as well. In 2019, I gave a global TED Talk titled "The Enduring Legacy of Ballroom." In it, I used as a guidepost a template similar to Floyd-Thomas's five tenets of womanism to construct the six tenets of Ballroom. These tenets help us examine the significance of the community's history and contextualize its relationship to other historical and global struggles. The tenets also provide a framework for analyzing the community's response to marginalization and connection to death.

These six tenets help enliven the accounts that follow in these pages and put Ballroom in dialogue with a rich and robust history that is complex, intersectional, and global.

TENET 1:

BALLROOM AS A BLACK TRANS WOMANIST THEOLOGICAL DISCOURSE

Black trans women create the Harlem drag ball circuit as a theological response to the campaign of the Black Church that wants to rid Harlem of its Black queer constituents

Octavia St. Laurent and Tracey Africa were groundbreaking models, activists, and icons in the House/Ball community.

Dominique Christian Miyake-Mugler at the 2019 Heritage Ball at New York's Gramercy Theatre, during Black LGBTQ+ Pride weekend.

TENET 2:

BALLROOM AS A BLACK FREEDOM MOVEMENT

After World War II, the drag ball circuit migrates across the country to other cities that become "blacker," creating new spaces of freedom in response to systems of oppression.

TENET 3:

BALLROOM AS A BLACK TRANS FEMINIST POLITICAL/ ART COLLECTIVE

The Mothers of the House/Ballroom community emerge as the ball circuit morphs from the individual (drag ball) to the collective (House ball). The formation of Houses happens in dialogue with Black feminist politics of the late 1960s, and Ballroom's cultural productions constitute an art collective that is also in dialogue with other art collectives forming in the 1970s as responses to a

The iconic dark and lovely Chastity Moore, aka Tempress Maison Margiela, was Queen Mother and one of the founders of the Haus of Maison Margiela. She is seen here competing in the Femme Queen Face category at the Evisu Ball in 2008 in New York City, where the prize was $5,000.

Willi Ninja was a dancer and choreographer who brought a unique style to voguing in the 1980s and 1990s.

TENET 4:

VOGUE AND PERFORMANCE AS AN ORGANIZING TOOL, A HERMENEUTICS OF THE BODY, AND A HOMILY

Ballroom uses its emblematic cultural production dance form, vogue, to organize and create other Ballroom geographical regions across the nation. Additionally, lip sync performances by trans women become the mode to contextualize both the joys and pains of an entire community, as well as to minister to it, particularly during the height of the AIDS crisis.

TENET 5:
BALLROOM AS A RADICAL PEDAGOGY

Ballroom creates pedagogical responses to the increasing prevalence and incidence of HIV and its impact on Black/Latinx gay men and trans women. Additionally, as deaths within the Ballroom community increase, Ballroom responds with intraventions (community-based strategies and solutions to address issues)

Laverne Cox, a Ballroom community ally, is an actress and LGBTQ+ activist, including for HIV-related issues. She rose to prominence playing Sophia Burset on the series Orange Is the New Black. *The first transgender person to be nominated for a Primetime Emmy and to be featured on the cover of* Time *magazine, she actively advocates for the transgender community.*

In 2007, Los Angeles–based REACH LA put on its second Ovahness Ball. The theme was "America's Next Top Ball Kid."

TENET 6:

BALLROOM AS A SPIRITUAL FORMATION: THE RADICAL INCLUSIVITY, THE BELOVED COMMUNITY, AND THE BLACK CHURCH

Ballroom provides the space for folk from all different theological backgrounds to develop a spiritual formation around what it means to make meaning out of their lives and their suffering. Part of that spiritual formation is the ethical imperative of radical inclusivity, creating space for everyone.

A performer walked at the Black Fantasy Ball, first held in Denver, Colorado, in 2021. The ball is hosted by Black Pride Colorado, a program of YouthSeen, an LGBTQ+ organization.

Kemar Jewel of the House of Lanvin showed off creativity, poses, and golden looks.

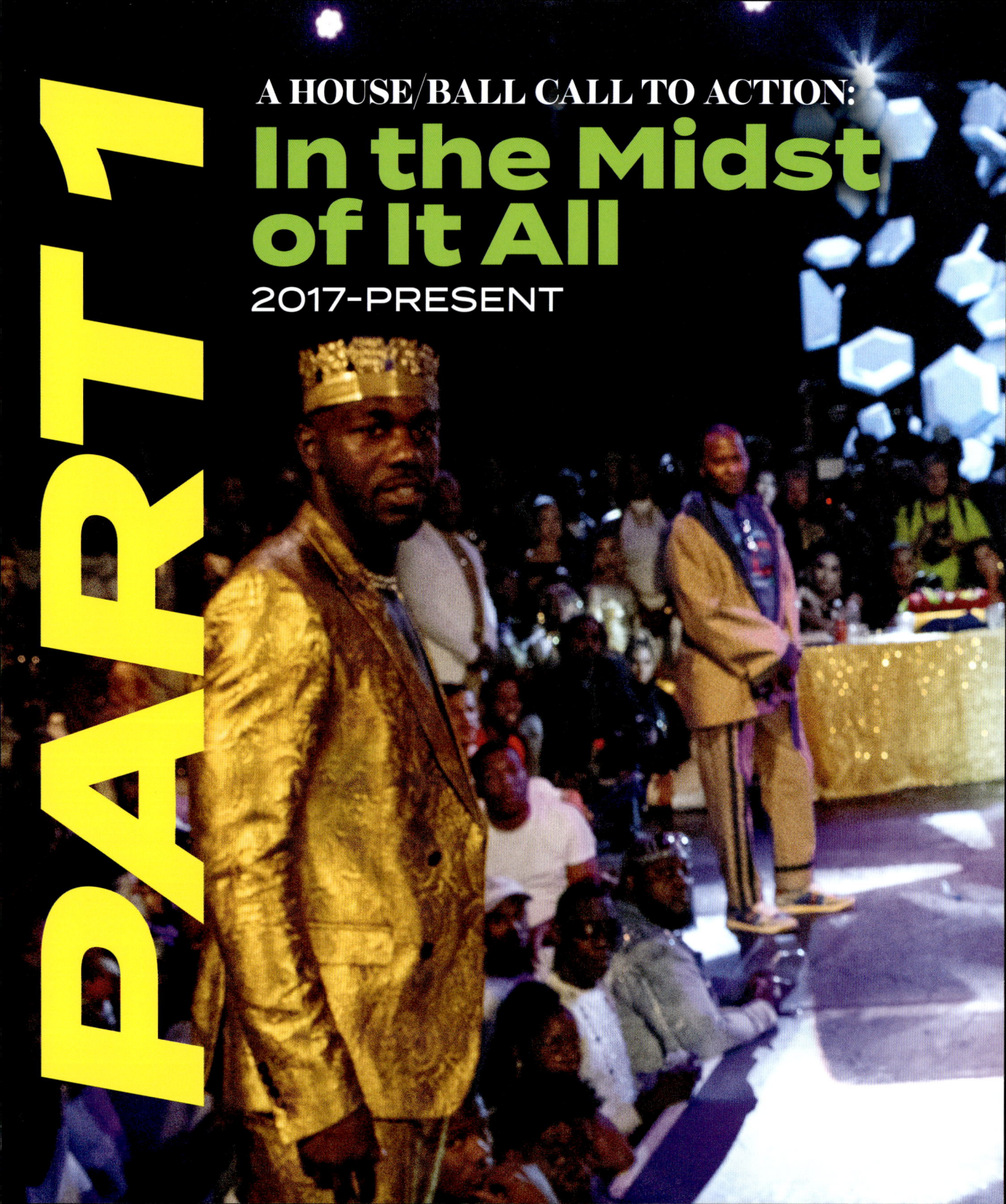

PART 1

A HOUSE/BALL CALL TO ACTION:
In the Midst of It All
2017-PRESENT

House Mother of the Atlanta chapter of the House of Xclusive Lanvin, Erykah Lanvin competed here in the open-to-all Face category at Miyake-Mugler's Porcelain Ball in 2019.

A competitor walked at the 2022 Black Pride Ball in the Netherlands, organized by House of Ninja's Zelda Fitzgerald Ninja and Dutch Prince Perry Ninja.

Ballroom is a global phenomenon. Over the past twenty-plus years, Ballroom and the community have migrated beyond North American shores, planting seeds in nations such as England, Scotland, France, Sweden, Russia, and the Netherlands; creating communities in Mexico and Brazil; making its presence known in Asia, including Thailand, Japan, and the Philippines; and establishing itself in Africa, in nations like Ghana and South Africa.

Ballroom is a community that has become multidimensional and is brimming with extraordinary talent, brilliant minds, powerful community organizers, and recognized public intellectuals.

In 2022 and 2023, Ballroom went through something of a renaissance. It found new cultural platforms, such as television, celebrity interest, and tributes by musical megastars. These platforms showcased Ballroom's talents, expression, and brilliance— and they introduced Ballroom to new audiences, making it visible to those who were unaware of its legacy.

The community created magic around the world even while it was forced to confront issues of the day, such as the anti-LGBTQ+ and pro-white supremacist sentiments that are part of today's geopolitics and that endanger democracy. This happened not only in the United States but also in places like Russia and Brazil, where fascist sentiments threaten the freedoms and lives of LGBTQ+ folk. Ballroom is the perfect counterculture response and resistance, creating spaces of freedom of expression and beingness for those most affected and targeted.

But all the attention presented Ballroom with a dilemma: What was previously a subculture gained new platforms, larger corporate sponsorships, and organizing power, among other changes. Ballroom, and the people in it, were forced to ask, *Who are we now?*

In order for us poor and oppressed to become a part of society that is meaningful, the system under which we now exist has to be radically changed. This means we are going to have to learn to think in radical terms. I use the term radical *in its original meaning—getting down to and understanding the root cause. It means facing a system that does not lend itself to your needs and devising means by which you change that system.*

—Ella Baker, from a speech at the Institute of the Black World (1969)

A contestant struck a fierce pose at the 2019 Black Fantasy Ball.

BALLS TODAY

In its simplest form, a ball is an event, a coming together of the House/Ballroom community to compete and have fun. But in its purest form, a ball today is one of the greatest and most effective community organizing tools of our time, a convergence of chosen family to protect and uplift one another. In the sense that balls are produced out of the community's ethos, struggles, and resilience, they are, in a way, extensions of the Black Church; they present opportunities for fellowship, moments for the community to be its most free and its most divine at the same time.

Here are seven examples of recent balls that illustrate what Ballroom is today. (Because New York City is, historically and currently, the Ballroom mecca, five of them were in New York.) These balls mostly took place in the same context as the rise of the MAGA Right and Donald Trump's election and the global COVID-19 pandemic. They got the community through, helped it resist the continued attacks and legislation against LGBTQ+ folk, kept us from being overly isolated during shutdowns, and—most of all—always provided a space of love for one another and for the community.

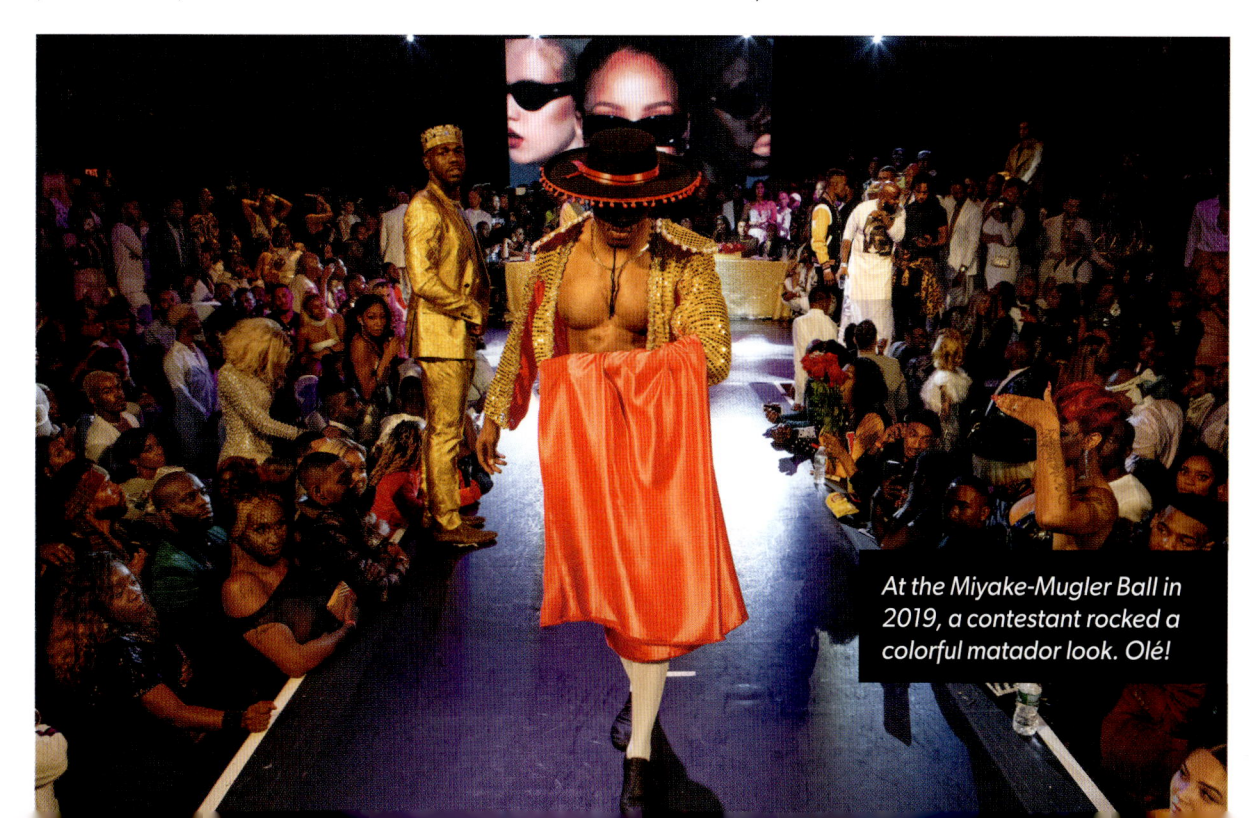

At the Miyake-Mugler Ball in 2019, a contestant rocked a colorful matador look. Olé!

This lovely duo graced the stage in the Femme Queen Face category at the 2016 Coldest Winter Ball in New York City.

Lee Soulja, executive director of NYC Center for Black Pride, has overseen NYC Black Pride celebrations since 2009. The Founding Father of the House of Soulja has a unique sense of style and fashion, in evidence at the 2009 Latex Ball.

THE STRUGGLE FOR FREEDOM: THE HERITAGE BALL

Created and organized by Lee Soulja (founder of the House of Soulja and executive director of New York City's Black LGBTQ+ Pride), Mike Haynes Ebony (Overseer of the House of Ebony), and me (founder of the Haus of Maison Margiela, although at the time I was a member of the Hall of Fame House of Milan), the Heritage Ball celebrates the legacy of both the House/Ball community and Black LGBTQ+ Pride, and highlights from both movements the history of the Black struggle for freedom.

Held in New York City on the third Saturday in August as part of Black Pride celebrations, this ball is one of the largest annual Ballroom events in the country. It's also free to the public and grounded in public health interventions such as HIV testing and STD screenings.

Unlike other balls, where the Houses in attendance gather behind their designated tables and watch and cheer with their members, the Heritage Ball doesn't have tables. The audience mingles, creating more opportunity for the performers to connect with the whole room. There's a call-and-response that's reminiscent of the Black Church, almost like the performer is the preacher and the audience is their congregation.

Although the first Heritage Ball took place in August 2015, the event made its mark on a national and international level in 2017, when it partnered with the House Lives Matter National Leadership Initiative and the Arbert Santana Ballroom Freedom School initiatives to bring together more than one hundred national and international Ballroom leaders, art collectives such as ARIKA from Edinburgh, Scotland, and artists/Ballroom leaders from São Paulo, Brazil, through support from the Musagetes Foundation. It was an homage to leaders, bestowing Legendary status upon folks that included Twiggy Pucci Garçon, Courtney Balenciaga, Tre Milan Maison Margiela, and Paris Gotti Ebony, and Icon status to the Legendary Arturo Miyake-Mugler.

HOUSE LIVES MATTER: LEADERSHIP AND RESILIENCY

The House Lives Matter (HLM) National Leadership Initiative is one of the Ballroom community's most effective community organizing initiatives and calls to action in recent years, and it has a wonderful and intentional historical lineage. Created by Dr. Jennifer Lee and co-conceptualized by Martha Chono-Helsley, former executive director of REACH LA, and me, HLM convened for the very first time in November 2016, the day after Donald Trump was elected president of the United States.

Given the high rates of HIV and STDs, youth homelessness, and Black/Latinx trans women being brutalized and murdered, HLM's objective was to develop leadership nationally within the Ballroom community to confront these intersectional disparities. It has now grown so tremendously that its impact and reach can even be felt internationally, with partners in Glasgow, Toronto, and Amsterdam.

HLM has proved to be one of the most effective public health intraventions, because it sits at the intersection of public health and community organizing, and because it goes beyond the traditional historical notions of articulating the House/Ballroom community through the pathological lens of illness, mainly HIV/AIDS disease. To be effective in addressing the intersectional disparities affecting the House/Ballroom community, HLM puts development of leadership and self-efficacy (the belief that one can do what needs to be done) at the core of its work, and so prioritizes the resilience of the community. It offers a community call to action in the midst of a sea of challenges.

HOUSE LIVES MATTER
presents

HOUSE BALLROOM LEADERSHIP
Convening 2019

NEW YORK CITY
AUGUST 14TH – AUGUST 18TH

ABOUT HOUSE LIVES MATTER:
THE HOUSE LIVES MATTER CONVENING IS THE ONLY PUBLIC EDUCATION FORUM IN NYC THAT FOCUSES ON THE HOUSE BALLROOM COMMUNITY (HBC). THE DISPROPORTIONATE IMPACT OF HIV/AIDS, AS WELL AS OTHER INTERSECTIONAL ECONOMICALLY ROOTED ISSUES THAT IMPACT THE HBC MAKES IT A VITAL TIME TO ADDRESS THE HEALTH INEQUITIES AND DISPARITIES THAT FACE OUR COMMUNITY. MOBILIZING THOSE AROUND THE COUNTRY AND WORLD THROUGH A HUMAN RIGHTS AND SOCIAL JUSTICE LENS PROVIDES LARGER OPPORTUNITIES TO UNIFY AROUND AN ADVOCACY AGENDA THAT BY REGION CAN ASSIST HBC MEMBERS WITH DOING WORK IN THEIR LOCAL AREAS. THIS CONVENING IS OPEN TO ALL LEADERS AND UP AND COMING LEADERS OF THE HOUSE BALLROOM COMMUNITY.

HOST HOTEL: **YOTEL 570 10TH AVE., NEW YORK, NY 10036**
FOR MORE INFORMATION, PLEASE CONTACT:
HOUSELIVESMATTER@GMAIL.COM | WWW.HOUSELIVESMATTER.ORG

House Lives Matter announced its 2019 gathering with a clear statement of the organization's purpose and goals.

BRINGING IT:
THE ALPHA OMEGA & THE COLDEST WINTER EVER BALLS

Enter the annual must-attend balls: The Alpha Omega (created by the Icons Caesar Alpha Omega and Jacen Bowman) and the Coldest Winter Ever Ball (created by the Icons Ceasar Williams and Sinia Alaia). Held in February in the cavernous Knockdown Center in Queens, these two balls alternate years. Both bring a lot of magic and big-space production values. Picture competitors walking a stage in a space so big that if they start from the back, they're tired by the middle of it.

First held in 2016, with big corporate sponsorship, these balls quickly became not only the largest-paid balls in New York City, but also across the nation. They lead the way in the amount of cash prize money offered to category winners. That means at these balls, the competition is fierce. Everything from the gowns to the attitude—people *bring it*.

In 2022, one of the top prizes for Coldest Winter Ever 4 was the category Femme Queen Sex Siren. The winner would be named the Queen of Sex, in honor of Sinia, who co-organized the ball. Four thousand dollars was handed out for the femme queen who could transform into a "high fashion sex siren nasty scandal looking like cash money," as the description explained.

Veronica Miyake-Mugler entered in all-black, stalking down the runway wearing a black dress with a plunging neckline and a high slit, showing off her stilettos, thigh-high sheer tights, and corset. The Icon Trace Gorgeous Gucci appeared from behind her House's flag, popping her chest to Vanity 6's "Nasty Girl" in a shimmering thong bikini and sheer, fur-trimmed white robe. However, the victor that night was the stunning Lola Gorgeous Gucci, the Overall Mother of that House. She was wheeled onto the runway in an all-white icebox, surrounded by billowing dry-ice vapor. The box's frosted windows showed Lola only in silhouette. Then she emerged, wearing teal fur and a crystal hairpiece—before stripping down to a crystalized white corset and thong, all while Aaliyah's "Rock the Boat" played.

Ballroom Pioneer Hector Xtravaganza, founder of the House of Xtravaganza, is seen here at the Coldest Winter Ball in 2016, two years before he passed away. He was also a cofounder of the Latex Ball project with GMHC.

FIRST IN THE FIGHT: THE LATEX BALL

Without a doubt, one of the most iconic balls ever, and absolutely the first in the fight with regards to the AIDS crisis, is the Latex Ball. A product of the Latex Project, founded in 1989 with the Gay Men's Health Crisis and House/Ball community leadership, the Latex Ball simultaneously raises awareness about the HIV/AIDS epidemic and acts as a tribute to and celebration of the lives lost in Ballroom to the epidemic. It's the oldest annual free ball in New York, held every year since 1993. The ball offers prevention screenings in addition to high-intensity Ballroom competition, and attendees include members outside the Ballroom community. It frequently reaches capacity, often turning guests away, and hosts celebrities such as Janet Jackson, who attended in 2006.

Known particularly for its performance categories, the Latex Ball has a high stage, spotlighting competitors and generating an undeniable energy in the room, even with 3,000 to 4,000 audience members. In recent years, its enduring legacy has helped get the community through particularly hard political times and targeted attacks on LGBTQ+ people.

The legendary Erykah Lanvin made a grand entrance at the Latex Ball in 2015.

POSE: A REVOLUTIONARY ACT

Transgender model and actress Indya Moore Xtravaganza, who played the role of Angel Evangelista on the TV series Pose, *is seen here during Season 1.*

In early 2017, chatter, debate, and pushback began to surface from folk of all sorts—community members, cultural ambassadors, pundits, and influencers—that there was a project that would bring the 1980s New York City Ballroom scene to television. It would be helmed by Ryan Murphy (*Nip/Tuck*, *Glee*, *American Horror Story*); one of his creative partners, Brad Falchuk; and writer Steven Canals, an Afro-Latino gay man from the Bronx who had recently received an MFA in screenwriting from the UCLA School of Theater, Film, and Television.

The chatter and debate covered familiar ground in a familiar history: here we go again—a story, this time by way of an announced television project, about Black/Brown queer folk would be told through the lens and authority of a white gay man. Although having Canals attached to the project eased some of the tension, the debate still made enough of an impact that Murphy and Fox Studios recruited members of the Ballroom community, including Twiggy Pucci Garçon and me, to become cultural consultants who would be in the writers' room as the show was being created.

I clearly remember feeling something magical, something that felt extra, like a sense of possibility in the universe, when I walked down the sun-drenched street to the Fox studio lot in Los Angeles for a meeting in Murphy's bungalow. Murphy had assembled a team that included writer and transgender rights activist Janet Mock; screenwriter, producer, and director Our Lady J; Canals; and me. We began work that day on conceptualizing two pilot episodes of *Pose*. They would be a test that we aced: the episodes were so well received that the series was picked up and ran for three seasons.

Over the course of developing and producing the series, many other members of the Ballroom community were brought on as consultants and lent their personal stories and talents to the show.

Pose debuted on FX on June 3, 2018. The series was successful in bringing together actors, dancers, performers, and models from the Ballroom community and explored its intersection in the 1980s and 1990s in terms of race, gender, sexuality, and class, confronting societal ills at the height of both the crack and AIDS epidemics. The show was set mostly in Harlem and on the piers in Greenwich Village at a time when the city's downtown literary scene was

AIRED ON FX FROM JUNE 3, 2018, TO JUNE 6, 2021

3 SEASONS

26 EPISODES

47 AWARDS AND 141 NOMINATIONS

growing and a new culture of young urban professionals (yuppies) was spreading. Storylines and fictional characters were inspired by the House/Ball culture and community, weaving in modeling, voguing, rivalries, and competitions. The show also featured diverse talents such as Patti LuPone, trans activist Cecilia Gentili, and directors Tina Mabry (*Queen Sugar*) and Silas Howard (*Transparent*, *Dickinson*).

In its first season, *Pose* was nominated for numerous awards, including a Golden Globe for Best Television Series—Drama and another for Billy Porter as Best Actor in a Television Series—Drama for his role as emcee Pray Tell. In 2019 Porter became the first openly gay Black man to receive an Emmy in the Lead Actor category, and the show was nominated for an Emmy as well. In its third and final season (2021), for the first time in the history of the awards, Michaela Jaé Rodriguez became the first trans lead to be nominated for an Emmy in the Lead Actress category.

Pose's legacy is historic, not only as a television show but as a model for what it means in Hollywood to work effectively with the community. Throughout its three seasons, *Pose* employed almost eighty mostly Black/Brown queer folk, largely from the House/Ball community, including background actors, makeup artists, stylists, choreographers, and production team members.

Pose was the first television show where nine of the original cast members were Black/Brown gay/queer men and trans women: Dominique Jackson, Billy Porter, Michaela Jaé Rodriguez, Indya Moore Xtravaganza, Angelica Ross, Hailie Sahar, Ryan Jamaal Swain, Dyllón Burnside, and Jason Rodriguez.

"POSE DEMANDS TO BE SEEN."

The New York Times

Dominique Jackson, Ballroom legend and Overseer of the Haus of Maison Margiela, dazzled in her leading role as Elektra Abundance on the TV series Pose, *as seen here in the pilot episode.*

Michaela Jaé Rodriguez (center) shown during a scene from Pose. *She was nominated for an Emmy Award for her performance in the role of Blanca Evangelista.*

"IT'S LIKE FALLING IN LOVE: HEIGHTENED, REVELATORY, BRUISING. POSE IS THAT GOOD."

The Guardian

LEGENDARY: MAKING HISTORY

[Pose] opened doors for a show like Legendary, *where now you get to see the real deal. It's raw and authentic, not scripted, not made up: a real ballroom experience.*
—Leiomy Maldonado, House of Miyake-Mugler (Grammy.com)

Ultimately, the question is, can voguing be appropriately appropriated? My answer is always the same: No, it can't.
—Benji Hart, "Vogue Is Not for You: Deciding Whom We Give Our Art To"

These sentiments reflect a debate that was raging in the Ballroom community at the time the *Legendary* reality show competition series aired in 2020. Some of the fundamental questions were: What is Ballroom becoming? What does it mean to be mainstream? What is its salacious relationship with both Hollywood and Europe? And because of these relationships, are we losing something valuable when we are no longer seen or operate as an underground scene?

The HBO/Max show *Legendary* made history as the first competition show with Ballroom as its focus. Each season, groups competed to be crowned the Superior House and win a grand prize of $100,000.

In his 2015 essay "Vogue Is Not for You: Deciding Whom We Give Our Art To," the artist, voguer, and community organizer Benjamin "Benji" Hart, formerly of the House of Ninja, cautioned that the heightened visibility of the Ballroom community was something to be mindful of; that there was danger in the Ballroom community exchanging the cultural production of Ballroom's emblematic dance form of vogue for hypervisibility and capital commodity. Hart warned that Ballroom would be at risk of losing its authenticity and its autonomy—the need for which made voguing so necessary in the first place—and even more so in a political climate infused with anti-trans, anti-LGBTQ+ sentiments.

Despite these differing points of view, *Legendary* dazzled the world, showcasing the House/Ball community's talent, stories, art,

Dashaun Wesley was the host on the Ballroom reality TV show Legendary. *A Ballroom Icon known as the King of Vogue, he is founder and Overall Father of the House of Basquiat.*

Legendary *gave Ballroom a monumental platform.*

and histories. Dashaun Wesley, founder of the House of Basquiat, served as host. The House of Balmain won Season 1 and the House of Miyake-Mugler took the top prize in Season 2. In Season 3, the Kiki House of Juicy (a House that is part of a younger subset of Ballroom with its own events and Houses), battled through and won, beating some powerful mainstream Houses.

There was tension about casting the judges for the show, many of whom were celebrities. Some felt that all the judges should have been members of the Ballroom scene. While *Pose* star, Ballroom Icon/Hall of Famer, and Overseer of the Haus of Maison Margiela Dominique Jackson was a judge for Season 1, community members criticized the show sharply for not having more names. Seemingly in response to that criticism, the star of *Star* (produced by Lee Daniels for Fox) a Ballroom Legend and Overall Mother of the Haus of Maison Margiela, was booked as a guest judge for the show's second season, while Jackson returned for the third.

Legendary was on the air for just three seasons, yet with Ballroom Icon/Hall of Famer Jack Gorgeous Gucci as a co-executive producer, it had a lasting impact. It presented Ballroom in all its magic, its wonder, its highly competitive edge, and its brilliance to people around the world who previously had little or no knowledge about it. It also gave the Ballroom community a larger platform on which to express its originality and authenticity, as well as its ability to expand its horizons.

The House of Comme des Garcons came in third on Season 2 of Legendary. *Shown here is Tonka Garcon, from the Atlanta chapter, ruler of the Big Boy category.*

The power and the artistry of female figure performance was on display at the Latex Ball in 2022 in New York City.

THE BATTLE CONTINUES: THE LATEX BALL 2018

In 2018, the Gay Men's Health Crisis (GMHC) put on its 28th annual Latex Ball, which was organized to raise awareness and testing for HIV. Hosted in the cavernous Terminal 5 on Manhattan's west side, the event welcomed more than 2,000 guests for a variety of categories with the central theme of Kingdoms of Africa. The theme called for competitors to walk categories dressed as a pharaoh, a sphinx, draped in kente cloth, or festooned with feathers, in hopes of winning some of the $10,000 in cash prizes.

Competitors came from around the globe. Jal Joshua from the House of Milan was a Filipino dancer based at the time in Australia who competed in the category Butch Queen European Runway. (A butch queen is a cis gay man. In Runway, you strut an outfit that might be seen on a runway show.) ChaChou Miyake-Mugler, from Paris, engaged in a vogue battle with Kassandra Ebony.

"Ladies and gentlemen, this is history," Jack Mizrahi Gorgeous Gucci said into the mic from stage. "Give this man, an icon of television, he has changed the motherfucking game: Mr. Ryan Murphy! You better work, honey." Murphy had been called to the stage to receive an award for the recently debuted *Pose*. Many of his cast and some of his crew were in the room: Ballroom Icon Dominique Jackson, an icon in Ballroom, was sitting on the judging panel, while others, including Janet Mock, Michaela Jaé Rodriguez, and Ryan Jamaal Swain, took quick bows onstage or mingled in the crowd. They were joined by community consultants Freddie LaBeija, Hector Xtravaganza, Jose Xtravaganza, and Sol Pendavis. But *Pose* wasn't the only House/Ballroom television show represented at the Latex Ball.

The Overall Father of the House of Miyake-Mugler and fashionista Yusef Miyake-Mugler competed at the 2018 Latex Ball. He is a celebrity hairstylist, including for Rihanna, whom he brought to the ball.

In 2018, the same summer that *Pose* premiered, Viceland debuted a new docuseries called *My House*. Created by Elegance Bratton, it followed Tati, Alex Mugler, Jelani Mizrahi, Lolita Balenciaga, Precious Ebony, and others as they navigated the scene. Many in the show were also at the ball. Some even competed.

The 2018 Latex Ball was a crowning achievement. Ballroom had become global, visible, a competitive behemoth, and understood finally as a way of life. It was the beginning of yet another evolution of a community forged from exclusion.

Competitors in the Runway category displayed futuristic looks at the 2018 Latex Ball.

THE LOVE BALL III

The first Love Ball was produced and held in 1989 at New York City's Roseland Ballroom as an HIV/AIDS fundraiser. It was a collaboration between influential members of the fashion industry and the iconic event promoter Susanne Bartsch. The team brought it back for Love Ball II in 1991, and between those two events, they raised more than $2.5 million for HIV/AIDS research. The third iteration, held thirty years after the first, highlighted that the fight for the lives of those who are most affected by the AIDS crisis still rages. Like its predecessors, Love Ball III brought together the House/Ball community and the high fashion community.

The very talented star of *Pose*, Billy Porter, was the June 2019 event's master of ceremonies. (Two years later, in May 2021, Porter broke his silence of fourteen years and publicly disclosed his HIV status.)

Love Ball III brought together a powerhouse array of Ballroom personalities and fashion socialites who acted as judges, including bombshell Amanda Lepore, actor and *Legendary* producer Jack Mizrahi Gorgeous Gucci, *Pose* director Janet Mock, *Pose* star Indya Moore, fashion designer Christian Siriano, and the late great André Leon Talley, who had been a judge at the first Love Ball. The event even brought together the Naomi Campbell of Ballroom, Dominique Jackson (also of *Pose*), and the real Naomi Campbell. Half a million dollars was raised.

Looking back, Love Ball III felt like an omen. It was an event to remind us about a pandemic that has affected countless lives. Months later, in 2020, a new pandemic would unleash itself on the world.

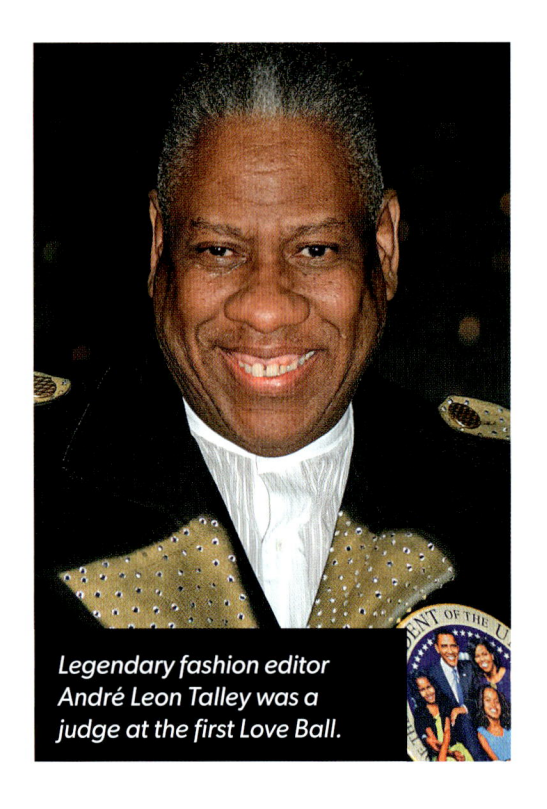

Legendary fashion editor André Leon Talley was a judge at the first Love Ball.

Seen here with Susanne Bartsch, emcee Billy Porter began the evening in dramatic canary yellow, the first of six outfits he wore that night.

Overall Father of the House of Garcon, Leryia Garcon looked sexy and magnificent at the 2019 Miyake-Mugler Ball in New York City.

PORCELAIN BALL: THE HOUSE OF MIYAKE-MUGLER'S 30TH ANNIVERSARY BALL

In 2019, the House of Miyake-Mugler celebrated three decades of existence with a blowout ball held in Times Square at the underground PlayStation Theater. The ball was the most anticipated of the year and included a sponsorship from Rihanna's Fenty Beauty company with a $10,000 grand prize for an open-to-all Face category—which at the time was the largest cash prize ever awarded for Face. (In Face, you sell your look from head to toe, but bring it with your face.) Rihanna herself judged the Face category, surprising attendees.

Walkers went all out. Jacen Bowman climbed out of a spaceship structure he had created. Overall Mother Dee Dee Lanvin arrived onstage in a birdcage to Minnie Riperton's "Lovin' You," wearing a golden mask with a beak. But it was Michel'le, in a custom gown featuring four tearaway reveals, who was the biggest hit. The ruffled organza of her train began to move by itself before it peeled off, revealing kneeling dancers with organza on their backs. For each of her battles, Michel'le modified the look, removing the skirt, the sleeves, and more.

Ultimately, it was Dee Dee Lanvin and her House daughter Erykah Lanvin who walked away with the prize, splitting the cash.

My child Twiggy Pucci Garçon, a runway choreographer on the TV series Pose *and filmmaker, is seen here walking the Runway category at the 2019 Miyake-Mugler Ball in New York City.*

A GLOBAL PANDEMIC: A GLOBAL PAUSE

February 2020 ushered in two of the biggest and most prestigious annual balls: the Annual Dorian Corey Awards Ball, created and organized by the Pioneer Architect of Philadelphia Ballroom, Alvernian Rafeek (currently the Overseer of the House of Du'Mure-Versailles); and the Alpha Omega House's Inaugural Ballroom Throwbacks Awards Ball. Two weeks later, on February 29, 2020, the first confirmed case of COVID-19 was diagnosed in New York.

For the first time in our lifetime, the entire world, all at the same time, was forced to stop, to take a pause. For the Ballroom community—whose ethos is all about gathering to enjoy one another's company and about movement—the global shutdown was a difficult one. But in true Ballroom fashion, it was also a time of real coming together, of organizing to help one another, a moment to demonstrate the importance of mutual aid and why the Ballroom community historically has taught the world about what it means to be one of the best in creating strategies to address public health disparities and global pandemics.

New York quickly became the epicenter of the virus in the United States. Ballroom's call to action was to create intraventions to address the impact COVID-19 was wreaking on the Ballroom community. One way I personally did this was to become a New York City COVID-19 contact tracer.

Among many issues COVID-19 illuminated were the historical inequities disproportionately affecting Black and Brown communities. Because of the pandemic, people lost their jobs, didn't have enough food to eat, and experienced social isolation. Stepping up, the House/Ball community raised money through mutual aid to support community members experiencing monetary, housing, and food insecurities. Ballroom initiatives such as Ballroom, We Care (BWC) responded by hosting virtual community forums and mental health check-ins. House Lives Matter gave about $20,000 in mutual aid to Ballroom community folk nationally.

When the world witnessed the murder of a Black man named George Floyd by the hands of police officers in Minneapolis on May 25, 2020, the Black Lives Matter movement was reignited. Five days later, in the same city, a Black trans woman named Iyanna Dior was beaten and brutalized in a store by a mob of angry Black folk. Because there was little coverage and accountability for Dior, the Ballroom community responded almost immediately, launching multiple campaigns.

Once the COVID vaccine was created and started to be rolled out, House leaders collaborated with community-based organizations to get their members tested and vaccinated. Camp Ballroom in Dallas, Texas, received funding to expand awareness about COVID-19 testing and vaccinations for the House/Ball community. The *Pose* team even produced a virtual ball hosted by the show's cultural consultant and choreographer, Twiggy Pucci Garçon. Attendees celebrated the show's three seasons and the community's support, attracting more than 360,000 views across all FX social platforms.

As New York State started lifting restrictions, Ballroom community leaders J'Lin Lanvin, Omari Oricci, and Courtney Balenciaga organized a Ballroom family-day picnic in the park for New York and New Jersey community members. Balls were soon to begin again in New York. The picnic led to the formation of the New York/New Jersey Ballroom Alliance, which ushered in a kind of peace, togetherness, and unity.

As has happened with so many challenges that the House/Ballroom community faces, COVID-19 reminded many of how magnificent Ballroom is as a community—a safe space, a space of discursive wrestling, a fellowship of belonging—and what it means to so many people. Even when faced with a global pandemic, Ballroom rose to the occasion, and we took care of one another like we always have.

CELEBRITY: MARY J. BLIGE'S STRENGTH OF A WOMAN FESTIVAL PURPOSE BALL

Queen of hip-hop and soul Mary J. Blige held her annual Strength of a Woman Festival in Atlanta in 2023, but that year she made an intentional decision to include the Black LGBTQ+ community by also throwing the Purpose Ball on Mother's Day.

Collaborating with television personality and Ballroom legend Miss Lawrence Balenciaga, and cosponsored by Pepsi, Live Nation, and Gilead Sciences, the ball brought together both Ballroom folk and celebrities.

GOING INTERNATIONAL: TORONTO, PARIS, SÃO PAULO/BRAZIL, AMSTERDAM

International balls have become vital and important in helping to organize our notion of freedom. As the freedom to be oneself as an LGBTQ+ person came under increasing threat across the globe, many international balls became ground zero in resisting growing fascist sentiments and creating safe havens for finding community, for connecting and organizing—even in countries where being queer is criminalized. They create the necessary medicine to treat and cure a global ailment of fascism and hate.

Competitors worked it at 2023's Afro-Pride Ball in Belgium.

FEMME QUEEN FACE COMPETITION

A highlight of the Purpose Ball was the Femme Queen Face competition. There was tension in the room—and not only because of the $20,000 prize pot, the largest single-person prize in Ballroom history at that point. Miss Lawrence Balenciaga had made the surprising decision not to have any Ballroom members judge the category, bucking usual protocol. He wanted to do something different, so the judging panel included only cisgender women as celebrity judges, with Mary J. Blige herself head judge for the category. Miss Lawrence hoped the judging system would ensure a better sense of fairness.

The Pioneer Stewart Ebony, who has been in Ballroom for almost forty years, was the commentator for the category, chosen no doubt because of his great oratory skills and commanding presence. Raquell Lord Balenciaga and Stasha Sanchez Garcon, both Femme Queen Icons who put Atlanta on the Ballroom map, opened the category in stunning gowns and crowns, reflecting royalty and confirming that the audience would witness a hot battle. They were not competing but simply whetting the audience's appetite.

During the competition, the crowd was thrown into a frenzy when Overall Mother Jazell Tisci, a top contender in the category for the previous three years, came face-to-face with Overall Mother Shannon Balenciaga, who had recently led her House to the finals on *Legendary*. Overall Mother Michell'e Basquiat, a nationally renowned Beyoncé tribute artist, appeared onstage in an exact replica of a look her idol had worn four days before on her Renaissance tour.

But after the talented contestants gave their all under the bright lights, one person was crowned Queen of the Ball that night: Simone, a newer girl from the House of Tisci. Although there was much discussion afterward about having only celebrity judges for the Femme Queen Face category and a few others, the ball was highly successful, well attended, and in the end gave out a total of $70,000 in cash prizes.

CATEGORY IS
FEMME QUEEN FACE

Femme queen is the Ballroom term for trans women, and Femme Queen Face is an aesthetic competition category for trans women. It's all about beauty and glamour. Competitors are judged on their facial features—eyes, nose, complexion, facial structure, and more. Think Miss Black America pageant meets *America's Next Top Model*.

Shannon Balenciaga, Mother of the House of Balenciaga, made a definite statement at the Miyake-Mugler Ball in 2014. Her beauty and poise were undeniable.

The graceful seduction of the iconic Miss Michel'le dazzled as she competed in the Face category at the Miyake-Mugler Ball in 2019. She was Overall Mother of the House of St. Laurent at the time.

BEYONCÉ: THE RENAISSANCE TOUR

When Beyoncé dropped her album *Renaissance* in the summer of 2022, she announced that it was a tribute to both House music and Ballroom culture. Her comments set the community ablaze. Remembering how it felt when Madonna released and toured for "Vogue"—seeing so many representations of Ballroom cultural production on television and onstage but without any credit given—there was immediate worry about appropriation again. However, there was some relief when Beyoncé said her tour would reflect her inspirations. She signed up Ballroom talent to perform with her and be part of the production—tapping, for example, Honey Balenciaga and Kevin Jz Prodigy. (In fact, Kevin Jz is an iconic commentator in the Ballroom community whose distinct sound and voice—like a scatting jazz artist's—can be heard throughout Beyoncé's album and live performances.) Other Ballroom members, such as Darius Hickman and Carlos Basquiat, joined her on tour.

Beyoncé's staging, the look of the tour, and her choreography all reflected the vibrancy of Ballroom. More important, she used her platform to pay tribute to O'Shae Sibley in a note on her website after he was murdered in 2023, showing solidarity with the Ballroom community.

Honey Balenciaga (second from the right), who began voguing and competing in Ballroom as a teenager, was a singer and dancer on the Renaissance World Tour and appeared in the concert movie.

PART 2

FROM MASQUERADES TO BALLROOM:
The History of It All
1888-2016

The 2019 Unity Ball in Washington, DC, was presented by Icon Twiggy Pucci Garçon, Icon Duante Balenciaga, Icon Charles West, and Legendary Domo Alpha Omega.

1888
The Birth of Ballroom

While there are no known photos of William Dorsey Swann, who hosted the first-ever drag ball in the United States, the actor on the right was photographed playing Swann in a cake-walk dance in 1903.

It can be hard to ascertain the start of things, particularly for a community that has historically been demonized and legislated against. Many of the stories and intricacies of drag and Ballroom are found only in oral traditions, where history is passed down via generational stories. It's through these oral traditions that communities share cultural values and provide a counternarrative to the one told by and through the lens of folk who hold hegemonic power and make decisions about whose epistemology is privileged to be included in the lexicon of history. But through contextual analysis of the few resources we do have, alongside these oral histories, we can often create a narrative that tells a story that is as close to reality as possible.

Such is the challenge with tracking the chronology of the birth of both the modern and postmodern Ballroom community through the historical lineage of drag balls. What we do know is that the nation's capital is the setting of the earliest-known record of a drag ball in the United States.

On April 12, 1888, carriages arrived at 1114 F Street in Washington, DC, by cover of night. The horse-drawn vehicles delivered about thirty occupants. Dressed in suits and flashy silk and satin dresses, they ascended to the building's third floor, disappearing into a back room. There, a table was loaded with food, and wine, beer, and whiskey were available as well. Music played and couples danced, reveling in merriment.

In the corner sat a throne of sorts. It was for William Dorsey Swann, the Queen of the Ball, who was celebrating his thirtieth birthday.

Just before midnight, police burst into the room and bedlam broke out. Some of the partygoers fled, jumping out the windows and onto the roof of a nearby one-story building. At least one member of the group shattered the glass skylight of that building. Others shed their gowns, revealing themselves to be men as they attempted to flee the scene. But Swann fought back. After verbally arguing with the police, he resisted arrest. The police officers tore his short-sleeved white silk dress with lace overlay, which he had paired with gold-embroidered black slippers. The *National Republican*, which reported on the incident, described the

History isn't something you look back at and say it was inevitable. It happens because people make decisions that are sometimes very impulsive and of the moment, but those moments are cumulative realities.

—Marsha P. Johnson, from the documentary *Pay It No Mind* (2012)

altercation as "rough and tumble." But eventually Swann was subdued and at least ten others were arrested. A mob of onlookers followed, jeering, as they were taken to jail.

Swann was born enslaved in Maryland and became free when President Abraham Lincoln signed the Emancipation Proclamation in 1863. Swann found employment as a residential worker for William Wade Dudley, who had been the commissioner of pensions under Presidents James Garfield and Chester Arthur. (Dudley posted bail for Swann, which got him out of jail for that night's festivities.) The April 12 event was not the first nor the last ball Swann organized, nor was it the first time he was arrested. The prior January, he and six other Black men were arrested dressed in "corsets, bustles, long hose and slippers," according to newspaper reports.

The start of drag balls in the United States is often traced to Harlem in 1869, about two decades before Swann's arrests. In March of that year, the Grand United Order of Odd Fellows, a Black fraternal organization, held its first Masquerade and Civic Ball, which was open to the public. The ball was held in celebration of the organization's 25th anniversary. But whether this initial event, and the first few decades of other masquerade balls put on at the Rockland Palace in Harlem, was an actual drag ball is unclear. Some believe these early functions were not known for men attending in female attire and that they only gradually became part of the events in the early 1900s.

A story in the *New York Freeman* newspaper from 1888 talks about the grandeur of the costumes worn at the Masquerade and Civic Ball and says that the event was "distasteful to many Odd Fellows and their friends," but does not reference men wearing women's attire, which would have been major news at the time. Such mentions didn't appear in historical records until the early twentieth century. But with Swann's story there is no dispute. As a result of his arrests, his balls were covered in multiple newspapers, all of which remarked on the gender and attire of the attendees.

Swann's balls became sites of communion, safety, and even social education among their predominantly Black attendees. And Swann made history with his fight against incarceration.

Fred Bertsch was a partner in the Bertsch & Cooper advertising design firm, whose clients included the Packard Motor Car Company and Anheuser-Busch. He posed for this photo around the time the firm was founded in 1904.

GRAND UNITED ORDER OF ODD-FELLOWS CHART.

Disenfranchised Black Americans created the Grand United Order of Odd Fellows in 1843 and established lodges around the country, as both a social and charitable organization. Members provided mutual aid within their communities, including visiting the sick and offering financial assistance.

This building at 11th and F Streets (as seen in the early 1900s) was the site of Swann's first drag ball.

An illustration of a raid on drag balls.

RAID UPON A FANCY DRESS BALL

On January 13, 1896, Swann was sentenced to ten months in jail for the charge of "keeping a disorderly house," which was legal-speak for running a brothel. The inciting incident was another drag event that Swann held at his home on L Street. Swann petitioned President Grover Cleveland for a pardon, which was denied. US Attorney A. A. Birney wrote, "While the charge of keeping a disorderly house does not on its face differ from other cases in which milder sentences have been imposed, the prisoner was in fact convicted of the most horrible and disgusting offenses known to the law; an offense so disgusting that it is unnamed."

Swann's petition is regarded as the first political act of resistance by a queer American. It made him the face of both a radical politics and a subversive liberation theology for a very marginalized community of Black men who needed a safe and secret space to get up in drag and live out their truth. His was a public voice whose aim was to address the human condition of a people who were both disposable and disenfranchised.

Raids and arrests for simply dressing in drag, or hosting and attending a drag ball, were published in part to publicly shame the participants, such as this 1906 photograph from Chicago, Illinois.

Students in a history class at the Tuskegee Normal School for Colored Teachers in 1902.

IF NOT FOR . . .

While Swann's radical actions are part of Ballroom's origin story, as scholar and historian Henry Louis Gates Jr. said in a *T* magazine interview in 2011, "The thing about Black history is that the truth is so much more complex than anything you could make up." The historical and cultural context for Ballroom's birth and evolution shows the truth of Gates's observation. Before there could be a blossoming of Ballroom culture, several significant chapters in America's evolution had to be written.

- Enslavement in the United States: In January 1863, President Lincoln signed the Emancipation Proclamation, which freed Black Americans from slavery.
- Reconstruction: W. E. B. Du Bois called this time from 1860 to 1880 Black Reconstruction. It was a period of increased freedoms and opportunities for Black Americans, but it was also short-lived, and the backlash was powerful. The chief witness in Reconstruction, "the emancipated slave himself," Du Bois argued, "has been almost barred from court. His written Reconstruction record has been largely destroyed and nearly always neglected."
- The Rise of Jim Crow: Numerous laws passed in Southern states post-Reconstruction were designed to dismantle Black Reconstruction. They created a system of legalized racial separation and a second-class citizenship for Black people by denying them the right to vote and access to jobs. These efforts were supported by the 1896 US Supreme Court decision in *Plessy v. Ferguson*. The dismantling of "separate but equal" didn't begin until 1954's *Brown v. Board of Education of Topeka* that made segregation in public schools unconstitutional.
- The Rise of the Ku Klux Klan: The first white supremacist militia, a terrorist group, emerged from the wake of the Civil War and rose again in a backlash to Reconstruction. Their primary targets were initially Black people, and then later, Jews and Catholics.

- The Great Migration: Black Southerners migrated north in vast numbers—estimated to be as many as six million from the 1910s through the 1970s. They fled the Southern terrorism of Jim Crow and settled initially in Northeast and Midwestern cities like New York, Pittsburgh, Chicago, and Detroit, later expanding to the North and West. As a result of the Great Migration, New York City's Harlem became a cultural and intellectual Black mecca.

These five historical events laid the groundwork and served as prophetic witness to all that would follow—notably the artistic movement that emerged from post–Civil War Reconstruction and Jim Crow backlash: the Harlem Renaissance.

Humphreys Hall, the oldest building on the Cheyney University of Pennsylvania campus, was built in 1903. It is named for Quaker philanthropist Richard Humphreys, who bequeathed $10,000 to establish the first institute of higher learning for Black students.

AT THE SAME TIME...

During these major historic events, the blues, spirituals, and the birth of jazz composed the soundtrack for late-1800s Black people. Voices of Black resistance and dissent also made themselves heard. One was Frederick Douglass (1818–1895), the most eloquent of freed enslaved people and the most prominent abolitionist in America. There was Callie House (1861–1928), who historically has gone mostly unknown. She was also a former enslaved woman and became a leader of the National Ex-Slave Mutual Relief, Bounty and Pension Association, one of the first organizations to campaign for reparations for enslavement in the United States. And there was Booker T. Washington (1856–1915), a former enslaved man who became a prominent educator, and in 1881 the founder and first president of Alabama's Tuskegee Normal School for Colored Teachers, later known as the Tuskegee Institute and now Tuskegee University.

Booker T. Washington

Tuskegee has a rich and important legacy, but it wasn't the first place of higher learning established for Black students. Cheyney University of Pennsylvania, initially called the African Institute, was established almost fifty years earlier, in 1837. It was the first institution of higher learning for Black students in the United States, the oldest of what today are known as historically Black colleges and universities (HBCUs). The number of HBCUs grew rapidly after the passing of the Emancipation Proclamation in 1867, mostly in Southern states, providing the only choice for higher education available to Americans of African descent. Black Americans made a way where there was no way and created their own opportunities. The educators and students at these places of higher learning built and traveled a bridge from the Emancipation Proclamation to the early twentieth century.

The Hampton Agricultural and Industrial School, founded to educate emancipated enslaved and free Black Americans, was built on a former plantation in Virginia in 1868. Among its initial goals was to educate teachers who would then educate others, and it counts Booker T. Washington as a graduate. This photo, from around 1900, shows students in a chemistry lab.

Founded in 1865, Atlanta University was the first in the nation to award graduate degrees to Black students. This photo of four female students was taken around 1900. The school merged with Clark College in 1988 to form Clark Atlanta University.

Howard University in Washington, DC, began with a single building in 1867 and now comprises 14 schools and colleges and 143 programs of study. Its alumni include Thurgood Marshall, Zora Neale Hurston, and Kamala Harris.

Morris Brown College, founded by the African Methodist Episcopal Church, was the first educational institution in Georgia fully owned and operated by African Americans. It opened its doors in 1885 with 107 students and 9 teachers. This photo was shown in an exhibit at the Paris Exposition of 1900, an example of African American excellence achieved since Emancipation.

1919–1931
A Harlem Renaissance

The singer Bessie Smith was one of the mothers of the blues, a star among a group of musicians who created the soundtrack that accompanied the Harlem Renaissance and the era's expansion of the Harlem drag ball circuit.

W. E. B. Du Bois proclaimed in *The Souls of Black Folk* (1903) that "the problem of the twentieth century is the problem of the color line." The tension between race, gender, and sexuality was at the heart of the 1920s, especially in Harlem during a time known as the Harlem Renaissance. This tension inspired art, politics, and the theology of the Black Church and its respectability—an alchemy that created an explosion of creativity.

Jazz was the music of Harlem's streets. The Cotton Club and the Savoy were the most famous of the nightclubs where all this magic nightlife was happening. Sounds echoed from these and many other clubs—the horns, the trumpets, the drums, the vocals known as scatting. Improvisation was the soundtrack of a people who were part of a social and artistic revolution. The voices creating this new sound, in this new place, from these newly migrated and freed Black people, included the sounds of the underground from Black lesbian and transgender blues women, such as Ethel Waters, Gladys Bentley, Ma Rainey, and her protégé, Bessie Smith. Their lyrics were explicitly sexual, but their same-sex desire for other women had to be coded within lyrics that spoke of men.

A'Lelia Walker, the daughter of the self-made millionaire and Black beauty entrepreneur Madam C. J. Walker, was not as widely known as her mother, but she was known in her own way. In the early 1900s, she developed her own reputation for being an entrepreneur as well as an influential force among the Harlem elite. Part of that influence stemmed from her lavish parties.

Hosted in the brick-and-limestone townhouse she lived in (which had been designed by Vertner Woodson Tandy, the first Black architect licensed in New York State), the parties—which began in 1913—were safe places for liberal and radical ideologies as well as identities. "There was men and women, women and women, and men and men, and everyone did whatever they wanted to do," recounted one attendee, Mabel Hampton, who was a dancer, domestic worker, and early lesbian activist. Guests included Black luminaries such as the writers Langston Hughes and Countee Cullen; musician, composer, and bandleader James Reese Europe; entertainer, comedian, and top-selling recording artist Egbert "Bert" Austin Williams; singer

Institutionalized rejection of difference is an absolute necessity in a profit economy which needs outsiders as surplus people. As members of such an economy, we have all been programmed to respond to the human differences between us with fear and loathing and to handle that difference in one of three ways: ignore it, and if that is not possible, copy it if we think it is dominant, or destroy it if we think it is subordinate. But we have no patterns for relating across our human differences as equals. As a result, those differences have been misnamed and misused in the service of separation and confusion.

—Audre Lorde, from *Sister Outsider: Essays and Speeches* (1984)

HARLEM: A BLACK CULTURAL MECCA

I BELIEVE THAT THE NEGRO'S ADVANTAGES AND OPPORTUNITIES ARE GREATER IN HARLEM THAN IN ANY OTHER PLACE IN THE COUNTRY, AND THAT HARLEM WILL BECOME THE INTELLECTUAL, THE CULTURAL AND THE FINANCIAL CENTER FOR NEGROES OF THE UNITED STATES AND WILL EXERT A VITAL INFLUENCE UPON ALL NEGRO PEOPLES.

—JAMES WELDON JOHNSON, *HARLEM: THE CULTURE CAPITAL* (1925)

Langston Hughes

Josephine Baker

Jimmie Daniels

Nora Holt

Robert Earl Jones

Beauford Delaney

Madam C. J. Walker was born into poverty on a Louisiana plantation in 1867. As a young woman, she moved to the Midwest in search of a livelihood. Settled in Denver, Colorado, she launched her own line of hair-care products for Black women in 1905. She opened a beauty school, developed a Walker System of products, and employed a network of sale agents across the country. The first self-made millionaire in the nation, she became a philanthropist, funding scholarships for women and donating money to the NAACP and other worthy causes.

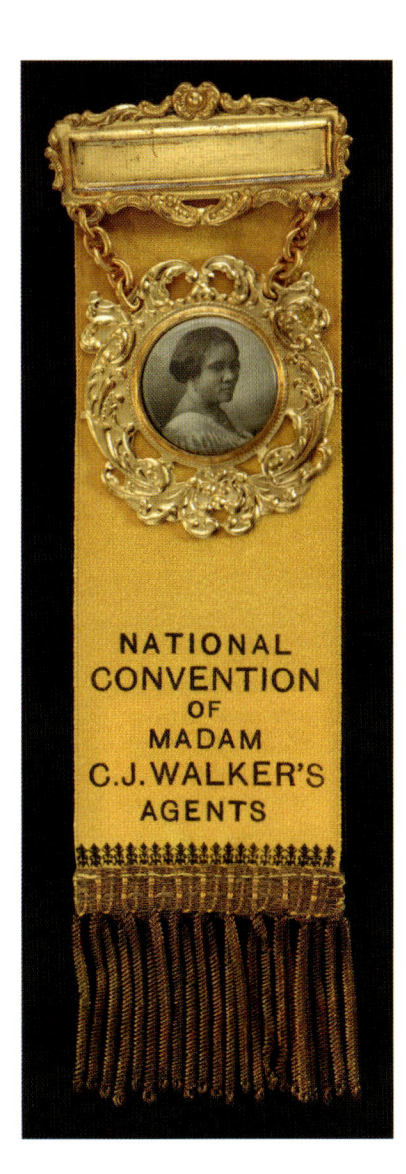

and dancer Florence Mills; actor and singer Paul Robeson; and writer Zora Neale Hurston.

Carl Van Vechten, a white critic and writer with a strong interest in African American artists and writers, attended Walker's parties and threw lavish ones of his own. He met Langston Hughes at a Harlem party and introduced the young writer to his own publisher in 1925. Hughes's first book of poetry, *The Weary Blues*, was published a year later.

There were other places of communion for Black queer folk in Harlem during this time. Harlemites hosted rent parties—lively events in peoples' homes with an admission fee to raise money for rising rents. There would be boisterous music, food supplied by the hosts and/or neighbors, and an extra charge for drinks.

The largest of these communal spaces were the balls, typified most prominently by an annual event hosted by the Hamilton Lodge No. 710 of the Grand United Order of Odd Fellows at the Rockland Palace up on 155th Street in Harlem. Originally called the Masquerade and Civic Ball when first held in 1869, by 1923 it was known informally as the Faggots Ball for its large attendance of cross-dressers. It featured attendees getting dressed up, many in drag, and dancing to live music. The ball was renowned for the grandeur of the attendees' costumes, and at one point during the night, the dance floor would be cleared and a runway set up to allow those who had dressed up to present their attire to the crowd. Prizes were given for the best masquerade.

In 1926, the *New York Age* reported that year's ball had some 1,500 attendees. "Although Hamilton Lodge is a colored organization, there were many white people present and they danced with and among the colored people," the paper noted, calling the ball "the most unusual spectacle." They also printed the names, races, and addresses of the masquerade winners.

These salons, rent parties, and balls ran counter to notions of Black respectability at the time, notably as voiced by Adam Clayton Powell Sr., activist and pastor of the influential Abyssinian Baptist Church, from his pulpit and in Black newspapers covering his sermons.

By 1932, Harlem nightlife included hundreds of restaurants, entertainment venues, and speakeasies.

"Homosexuality and sex-perversion among women has grown into one of the most horrible, debasing, alarming, and damning vices of present-day civilization," he said in a 1929 sermon. Among other things, Powell conflated homosexuality with pedophilia, warning that queer folk were likely to abuse children. The conflict between the church and the ball participants would come to a head soon after.

In February 1930, flyers and cards were handed out and ads were placed in the local penny press and the word was circulating. Not about the annual Hamilton Lodge Ball, dubbed the "strangest and gaudiest" of all Harlem spectacles by Langston Hughes, but about an upcoming sermon that Bishop Robert C. Lawson would give in response to it. The industrious preacher had promised his February 23 sermon would be a rebuke of "The Fairies' Ball," with a secondary headline of "The Faggots' Ball and What It Means in the Light of the Scriptures."

The *New York Age*'s May 1 coverage of the sermon was front-page news, billed above the murder of a mother of a sixteen-month-old baby at the hands of her husband. Lawson's Refuge Church of Christ had been packed to capacity when he gave the sermon the previous Sunday night, and now the newspaper coverage meant it would be disseminated to a much wider audience. Lawson claimed to have attended that year's ball, along with two parishioners, and said they were forced to park a block away from the Rockland Palace because of how popular the event was.

When he entered, "A sight that challenged description met our gaze," the newspaper quoted him as saying. "We were lost for words then, and even now, in a measure, to describe what we saw." Instead, he read from a report in the *Baltimore Afro-American*.

"From front to back, from side to side, from ceiling to floor, a colorful, hilarious mass of people surged back and forth," he read. "Every box, every loge, every stair and rail, was covered with eager people who had come—as early as ten o'clock—to see MEN WHO OUT-WOMENED WOMEN, AND WOMEN WHO OUT MENED MEN, and for their entertainment there paraded a collection of gorgeous creatures decked out in silks, satins, features and jewels, and for the first time, a goodly number of the correct tuxes on smart women with heavy, throaty voices."

Then, in his own words, Lawson described the balls as a widespread fad that were an "iniquitous traffic in degeneracy." According to him there were 500 men on the floor who "cavorted, squirmed and wiggled around with each other" while hundreds of others, both Black and white, watched from the balconies. He called out those spectators and participants who had left behind their Christian ideals, saying that as a result "children are not safe upon the streets any more, whether little girls or little boys, from these degenerate hyenas which seek to satisfy their base desires at the expense of youth."

This was the tension of the Harlem Renaissance: freedom and progress rebuked sharply, and even criminalized, by respectability. Drag balls became a liberated public space politically and reflected a type of theological response to a Black Church that castigated the attendees. These events served as a place of safety, a place of belonging, a place where people could be free, at least for the moment.

Balls created a theological discourse of mattering and belonging, and became the largest organizing movement, the largest countercultural response, to this theological homophobia. It is for this reason that I long have held the belief that these drag balls were also Black Church for Black queers, rooted in the radical subjectivity of Black trans women, and therefore, becoming a Black trans womanist theology, a theology of mattering, a theology of radical inclusivity, a theology of belonging, a theology of freedom.

The 1920s marked the pre-civil rights movement, with the aspiration and political agenda of racial integration. As a result of figures like Lawson and Powell, it did not include Black queers being given full inclusion within Black citizenship. But, poignantly and ironically, drag balls were fully integrated; the very thing that was ostracized was, subversively, the site of the integration the community so desired.

Lawson's sermon is indicative of a larger movement at the time. Balls had spread widely throughout New York City by then, with Madison Square Garden the venue for one in 1930. But in 1931, amid an overall crackdown on the so-called Pansy Craze

In the 1920s, Greenwich Village's Webster Hall, a gathering place for a bohemian following, welcomed the gay community who attended its balls in drag.

and gay nightlife, police began shutting them down. On September 26, 1931, the police forced a ball organizer to cancel his event at the New Star Casino, at Park Avenue and 107th Street. The following week police showed up at a hall on West 146th Street to prevent another drag ball from opening. Though Hamilton Lodge's event would thrive well into the 1930s, and other uptown functions like 1932's Arabian Nights Ball would continue to be held, the downtown scene was wiped out.

A'Lelia Walker, who frequented the balls herself and even brought Langston Hughes to some, died in 1931. Her death did more than end her parties and patronage of the balls—some of which she was known to have backed financially. (This spoke to a relationship cis Black women have long had with Black gay men in support and protection of their lives.) "That was really the end of the gay times of the New Negro era in Harlem," Hughes wrote of Walker's death. But although it was the end of an era, these events in Harlem became the ancestors of the modern House/Ball community that began in the late 1960s and that today has become a global phenomenon.

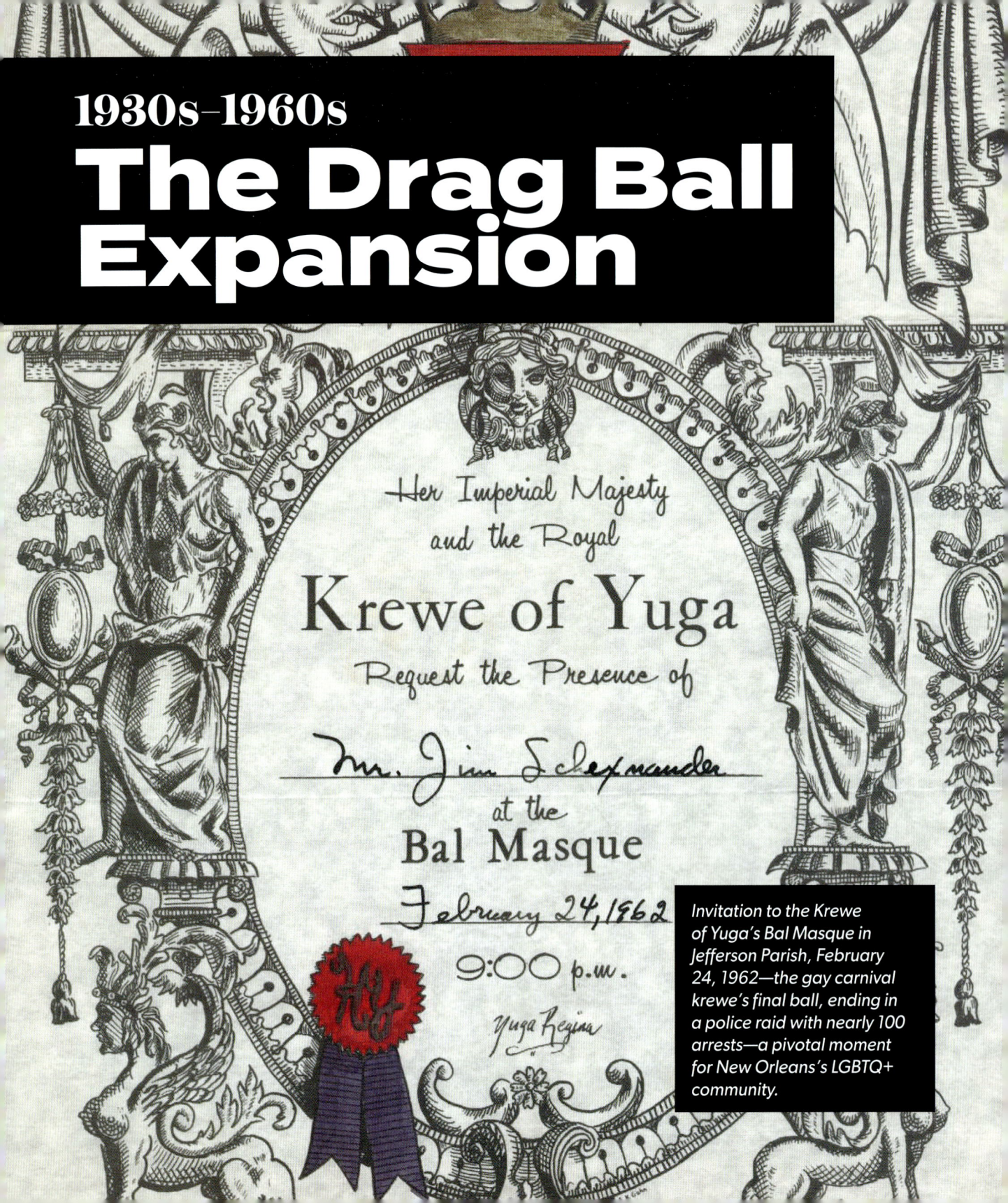

1930s–1960s
The Drag Ball Expansion

Her Imperial Majesty
and the Royal

Krewe of Yuga

Request the Presence of

Mr. Jim Schexnander

at the
Bal Masque
February 24, 1962
9:00 p.m.

Yuga Regina

Invitation to the Krewe of Yuga's Bal Masque in Jefferson Parish, February 24, 1962—the gay carnival krewe's final ball, ending in a police raid with nearly 100 arrests—a pivotal moment for New Orleans's LGBTQ+ community.

If William Dorsey Swann organized some of the first, more casual iterations of the balls that would lead to the House/Ball community, then Harlem showed the heights of what was possible. Those who flocked to the Hamilton Lodge Ball at the Rockland Palace came from up and down the East Coast for a peek at, and to compete in, the much-discussed event. In 1930, the *New York Age* reported that "a number came from as far as Chicago." And though they did travel, it wasn't long before Chicagoans had something back home to brag about.

As the Great Migration continued, Black residents formed communities in cities beyond the Northeast. In the 1930s, the Bronzeville neighborhood of Chicago surged, and was home to influential figures such as musician Louis Armstrong, journalist and activist Ida B. Wells, singer Nat King Cole, and poet Gwendolyn Brooks. Within this community, there was some acceptance not only of gays and lesbians but of professional working drag queens, who were respected for their ability to earn a living.

On Halloween in 1935, people could pay twenty-five cents to get into a party in the basement of a tavern at the corner of 38th Street and Michigan Avenue in Bronzeville. The interracial function featured men dressed in drag, likely drinking and dancing, though it's unknown whether a prize was awarded at the inaugural event.

Finnie's Masquerade Ball became the city's biggest and most well known of these. Alfred Finnie was a street hustler and a gambler. Not much is known about the man, except that he organized the roving balls that traveled from venue to venue until his death in 1943 (he was killed in a dispute related to one of his bets). By that time, Finnie's Masquerade Ball had become a staple of Chicago's South Side, and continued, organized by "Finnie's Club" after his death, for decades. The balls drew up to 3,000 attendees and attracted coverage from local publications such as *Chicago Defender*, as well as *Ebony* and *Jet* magazines. At these balls, the Queen of the Ball was awarded a trophy and cash.

At the time, cross-dressing was illegal in Chicago. From 1851 until 1973, a city statute mandated a fine for anyone who appeared "in a public place in a state of nudity, or in a dress not belonging to his or her sex." The fine was to be "not less than

The struggle can be won without brutalization. Our power is in our ability to make things unworkable. The only weapon we have is our bodies, and we need to tuck them in places so wheels don't turn.

—Bayard Rustin (1956)

twenty dollars nor exceeding one hundred dollars"—at a time when the average fine for other crimes was five dollars. In 1911, politicians doubled down, convening a vice commission that released a report condemning cross-dressing, among other things.

But Finnie, and other ball organizers across the nation where cross-dressing laws were enforced, used social norms to his benefit. He organized his balls around Halloween, when masquerades were typical, to evade unwanted police attention.

Similarly, in 1958, the Jolly Jesters Social Club in St. Louis, Missouri, turned their annual Halloween party into Miss Fannie's Artists' Ball, featuring female impersonators. Prize categories included Best Female Impersonation, Audience Favorite, and Best Dressed. The event raised funds for various causes in the local Black community.

"It was common practice to apprehend and arrest the contestants upon their exit from the Masonic auditorium after 12 o'clock midnight," Sherie White, who won the event in 1971 and 1976, recalled in 2017 in a talk at Washington University in St. Louis. "They were hauled into jail and sent to court, whereupon they were charged with the term *masquerading*."

When St. Louis's masquerading ordinance was overturned in 1986, organizers began to move the event to other weekends.

◊◊◊

Organizing balls in cities beyond the Ballroom community's Harlem origins—in Chicago, St. Louis, Philadelphia, Detroit—was a Black freedom movement. Freedom movements migrate and expand, looking for, finding, and constructing new places of freedom. These balls were constructions of freedom, where even for a night, gay, lesbian, and other gender-variant people could express themselves freely and be praised for it. "The way to right wrongs is to turn the light of truth upon them," observed Ida B. Wells. As balls spread across the country, they also helped turn the light on this growing Black freedom movement.

Detroit became a large Black metropolis, and experienced a large Black drag craze. Historical scholar Thaddeus Russell wrote

in a 2008 article in the journal *American Quarterly*, "From 1949 through 1954, the city's leading black newspaper, the *Michigan Chronicle*, featured in virtually every issue at least one and as many as five advertisements for drag shows in the Black business district of Paradise Valley, and regularly gave them enthusiastic coverage. Drag performers such as Janis LaCava, Baby Jean Ray, Zorina LaCrosse, Caledonia Anderson, Patricia Van Dyke, Nina Mae McKinney, and 'The Fabulous' Priscilla Dean were celebrities in postwar, pre-civil rights Black Detroit. The Black press praised them as 'stellar artists' who were among 'Detroit's most talented and imaginative entrepreneurs.'" Drag shows and drag balls often overlapped, and many of the drag queens or female impersonators participated in both.

Baltimore's so-called Pansy Balls, first held in 1931, were structured in the tradition of debutante balls. Held in early March at the Monumental Elks Lodge No. 3 on the corner of Madison Avenue and McMechen Street, they became a feature of local gay society, allowing attendees to "come out" to the community. The balls attracted hundreds, and were attended by people traveling from DC, New York, and Philadelphia.

The balls were intended as a debut into gay society, and some people trace the origins of the phrase to "come out"—meaning to publicly reveal one's sexuality—to these events. The balls were often closed to the public, though their popularity brought spectators, who were allowed into the balcony. Local publications like the *Baltimore Afro-American* covered the festivities, reporting on the crowds that lined the sidewalk hours before the balls began to catch a glimpse at the extravagant costumes.

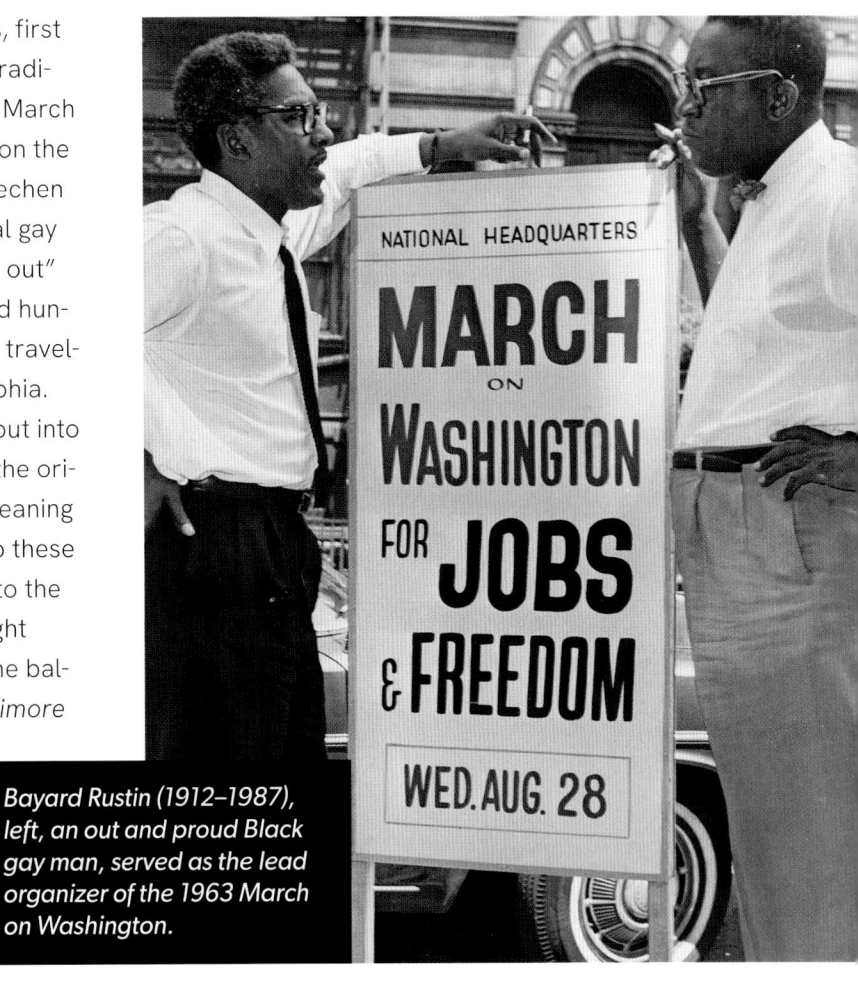

Bayard Rustin (1912–1987), left, an out and proud Black gay man, served as the lead organizer of the 1963 March on Washington.

While many spectators were appreciative, some jeered. In a 1932 report, the *Afro-American* wrote that a woman pushed through the crowd of onlookers, berating one attendee headed into the covered canopy for entry to the hall. "What do you want to go in there with those freakish hussies for?" she yelled. "Come on home."

"Amid the howls of laughter, the man beat a sheepish retreat," the reporter wrote.

Attendees exhibited a level of steeliness to walk that gauntlet, in fur coats worn over black taffeta dresses, beaded gowns, and ostrich feather fans. Once inside, there was food, drink, and merriment alongside live music. And the freedom to be themselves.

Meanwhile, in New York City, Mayor Fiorello La Guardia prepared for the 1939 World's Fair by cleaning up the city. As a part of this effort, gay bars and drag queen events were forced out of Times Square and moved south below 14th Street or north above 72nd Street. In the years that followed, the New York State Liquor Authority began to target establishments that were frequented by gay men and drag queens.

Nationwide, policies such as banning homosexuals from all branches of the military in 1943, and others that would set the stage for the Lavender Scare in the 1950s, set off a wave of repression that resulted in many gay and lesbian men and women being fired or forced to resign from jobs as a result of their sexuality.

Against this proliferation of homophobic policies, balls continued to evolve. Beginning in the mid-1940s, over the Thanksgiving weekend, Phil Black threw an annual Funmaker's Ball in the Rockland Palace ballroom in Harlem. Black, who often went by the same name in and out of drag, was one of the most popular drag performers of his time. He had studied fashion design in school and made most of his own gowns, although he developed such a following that Josephine Baker was known to loan him a few.

Black was the chief promoter and originator of the Funmaker's Ball, which became a successor of sorts to the shuttered Hamilton Lodge Ball. For the first twenty-five years, in fact, the popular social event was held at the same Rockland Palace venue, before moving to other spaces. Sanctioned by the police, who turned a

blind eye, the event would begin around 8 p.m. and end at midnight sharp. The balls attracted up to about 3,500 attendees. Spectators crowded the balconies, halls, and boxes, trying to get a glimpse of the hundreds of lavishly costumed impersonators.

At Black's Funmaker's Balls, those given trophies were the forerunners of the current Ballroom category of Realness—the ability to totally transform yourself and really sell the illusion. "The prizes do not go necessarily to the most beautiful persons but to those whose total impression, clothing, makeup, hair, movement, and overall behavior is the most pleasantly feminine," the *National Insider* reported in 1969. At times, Black would even lay down prize rules: winners are not allowed to weigh more than 150 pounds or have a bust of more than forty-two inches while wearing false boobs. For those who could make it through, there was $500 on the line and the title Queen of the Ball.

In 1963, the Committee for Racial Pride and Black nationalists picketed the ball with signs that read "Rear Admirals Stay Downtown," protesting that homosexuality and cross-dressing were evil perversions inflicted on the Black uptown community by white bohemians from downtown in Greenwich Village. The picketers harassed attendees so much that Black decided to cancel the 1964 Funmaker's Ball—the first one to be canceled. The next year, 1965, Black also canceled the ball due to illness. The Funmaker's Ball returned in 1966 and continued until his death in 1975.

Throughout his career, Black made a name for himself as a drag performer. He was known for a song-and-dance number that featured high kicks. His popularity took him to Montreal and eventually to Europe, and catching one of his shows became a must-stop tourist destination. He even developed enough of a reputation that private detectives would contract him to try to seduce husbands suspected of cheating, and he was a member of both the Negro Actors Guild of America and the American Guild of Variety Artists. He appeared in an uncredited role in the highly successful film *The Pawnbroker* (1964) and labeled himself America's Greatest Sepia Star. His Funmaker's Ball was an unmistakable part of his great legacy.

The Pawnbroker *(1964), a groundbreaking film directed by Sidney Lumet, featured Phil Black in an uncredited role, showcasing how diverse talents within the Ballroom community were featured in mainstream cinema.*

1931

The Hamilton Lodge Ball awarded top prize to a Black contestant for the first time, Bonnie Clark. The Hamilton Lodge Balls were shut down by the New York district attorney in 1937.

Phil Black (c. 1910–1970s), a renowned female impersonator, captivated audiences with his performances in nightclubs and theaters during the 1930s and beyond.

1939

In advance of the World's Fair, New York City began closing all known gay bars.

1935

Alfred Finnie organized his first Halloween-themed Masquerade Ball in Chicago.

1956

Miss Fannie's Artists' Ball, the first in St. Louis, Missouri, launched an annual tradition that continues today.

1965

The Mardi Gras Ball on New Year's Day in San Francisco, California, was the first to be organized by a Christian organization, the Council on Religion and the Homosexual. Raided by the police, it is often referred to as San Francisco's Stonewall.

Mid-1940s

Phil Black organized the first Funmaker's Ball at Rockland Palace, former venue of the Hamilton Lodge Balls.

1967–1972

Enter Crystal LaBeija

Crystal LaBeija (1930s–1982), a legendary figure in the Ballroom community, founded the influential House of LaBeija. Her commanding presence and pioneering spirit profoundly shaped modern Ballroom culture.

Twenty-four drag queens were packed onto the stage at Town Hall, a performance space in the heart of New York City's theater district. It was 1967, and the stage was practically bursting with contestants for the Miss All-America Camp Beauty Pageant. Emcee Flawless Sabrina stood at one side, her blond wig swept up and perfectly molded into a bouffant, a white fur stole draped on her arm, and glasses perched on the end of her nose. She affected an air more authoritative and wiser than her actual age might suggest. It was *her* event: the national title for a contest she had strung together, territory by territory, in places as varied as Boston and the Ozark Mountains, in the years since putting on her first drag show in 1959.

The judges, including artists Andy Warhol and Larry Rivers and journalist and writer George Plimpton, sat in the audience. At one point during the evening, drag act and New York City nightlife superstar Mario Montez gave a performance to "Diamonds Are a Girl's Best Friend" that featured bubbles. As the competition progressed, the contestants were narrowed to five finalists: Miss New Jersey, Miss Chicago, Miss Manhattan, Miss Philadelphia, and Miss Boston. They took to the stage, two in white gowns, two in silver, and one in a flowy shock of blue, in a moment that became an inflection point in history.

With the cord of her microphone snaking behind her, Flawless Sabrina's stern, almost-shrill voice cut through the performance space. "Our third runner-up in the 1967 Nationals," she said, "from Manhattan: Miss Crystal, ladies and gentlemen. Let's hear it for the third runner-up for the 1967 Nationals." From the stage, Crystal LaBeija's pink-painted lips mouthed the words, "Oh my god."

Stepping out of the lineup, Crystal continued mouthing her shocked words. Her black hair was piled high in a beehive held back by a shimmering headband, and her stole—its white feathers matching the ones that lined the bottom of her silver gown—dragged along the floor. As she took her position at the side of the stage and waited for the winner to be crowned, she wore no pageant grin. She was visibly bristling, simmering. Believing the whole production was fixed, Crystal decided to leave before the judging concluded. She reached for the banister and began to descend from the stage.

Above all else, Our politics initially sprang from the shared belief that Black women are inherently valuable, that our liberation is a necessity not as an adjunct to somebody else's but because of our need as human persons for autonomy.

—Combahee River Collective Statement (1977)

"Crystal, where are you going?" Flawless Sabrina asked. "This is not the time to show temperament. Get back here and stay with the other finalists."

The stage lights glinted off Crystal's chandelier earrings as she made her dramatic exit, sashaying through the crowd to scattered applause.

"Oh well, you've got to expect losses," Flawless Sabrina said, and then continued.

The incident, captured in the 1968 documentary *The Queen*, which screened at the prestigious Cannes Film Festival, is said to have been a maturation of ongoing issues with colorism and race in the pageant circuit. Crystal, a Black trans woman, lost, and Rachel Harlow (Miss Philadelphia), a white trans woman and Sabrina's protégé, won. According to Crystal, Sabrina had arranged for Rachel to win.

The echoes of that moment are still heard today. On the lauded FX series *Pose*, Blanca Evangelista and Elektra Abundance discuss it in the Season 2 premiere. Frank Ocean has referred to Crystal LaBeija at least twice, even sampling her voice on his visual album, *Endless*. And drag stars like Aja have channeled the fiery figure on *RuPaul's Drag Race All Stars*.

For many within the House/Ball community, this was the inciting incident of the modern Ballroom scene. Ready for the adulation she deserved, within a few years Crystal started something of her own.

In 1972, Crystal and Lottie, a fellow Black drag queen, began passing out flyers for a new event. They read, "Crystal and Lottie Present the First Annual House of LaBeija Ball at Up the Downstairs Case on West 115th Street & 5th Avenue." Although she lost that 1967 national contest, Crystal was one of the few Black queens to win Queen of the Ball at a major event, and had reigned as Miss Manhattan in the pageant world, so it made sense to name the ball after her. Plus, she counted legendary drag performer Phil Black as a supporter.

Phil and Lottie encouraged Crystal to strike out on her own and form the House of LaBeija. The move to organize a ball by "House" was transformative. After Crystal and Lottie's Ball, other Houses

Crystal LaBeija, resplendent and defiant, as captured in the groundbreaking 1968 documentary The Queen, *showcasing the glamour and complexity of Ballroom culture.*

began to form, including the House of Corey, from Dorian Corey, in 1972, and the House of Dupree, from Paris Dupree, in 1975. The introduction of the House system—created by Crystal and Lottie—gave rise to an entirely new drag ball circuit. From those Houses, we get the modern House/Ballroom community that exists today.

At the same time that Crystal and Lottie were forming the House of LaBeija, vast political unrest and turmoil gripped the United States in reaction and resistance to a system of hegemonic and oppressive power. The 1960s saw the rise of the Southern civil rights movement, protests against the war in Vietnam, and the devastating aftereffects of the assassinations of John F. Kennedy (1963), Malcolm X (1965), Martin Luther King Jr. (1968), and Robert F. Kennedy (1968). By the early 1970s, New York City was on the brink of financial ruin, and the political strategy to stave off bankruptcy was "planned shrinkage," which cut social programs and services and had an outsize impact on the Black community.

During this period, the Black Power movement was rising and the feminist movement was in full flight. Strong voices belonging to Black women and Black feminists emerged, in critique of both the racism and patriarchy that affected the Black community, and Black women specifically. In alignment with these voices in many ways, Crystal and Lottie created a new system, grounded in Black trans politics, that privileged the lives and voices of Black trans and drag performers.

Crystal LaBeija's act of resistance in 1967 served as the beginning of the modern House/Ballroom system, stemming from the ethos of Black trans women and making a distinction between Black trans experiences and those of their white counterparts.

While all these changes were happening, another movement emerged. In the summer of 1969—two years after Crystal's defiance and a few years before the House of LaBeija's first ball—a community Gary David Comstock described in *Gay Theology Without Apology* as "raging queens and butch dykes" resisted police harassment at the Stonewall Inn in New York City's West Village. The uprising, which went on for six days, is considered the launching point of the gay rights movement. The first Pride march was held a year later, on the anniversary of the Stonewall Uprising.

Only the Black Woman can say "when and where I enter, in the quiet, undisputed dignity of my womanhood, without violence and without suing or special patronage, then and there the whole Negro race enters with me."

—Anna Julia Cooper, A Voice from the South (1892)

While Martin Luther King Jr. fought for civil rights in the South, Black trans women and drag queens organized their own liberation through drag balls, which evolved into the House/Ball culture, asserting their right to exist and express themselves freely.

In the years that followed, white gay men had the economic ability and power to construct neighborhoods—geographical regions that were formed out of their cultural, political, and economic norms—such as Chelsea in New York City, the Castro in San Francisco, Boystown in Chicago, Adams Morgan and Dupont Circle in DC, West Hollywood in Los Angeles, and Midtown in Atlanta. But what did these neighborhoods mean for the Black and Brown gay men, the trans women, and other bodies who did not share those norms and possibly didn't share the same economic means or political access? In lieu of creating neighborhoods, taking over physical spaces in a permanent way, an intracommunal network of Houses formed, congregating around balls and other events. The House/Ballroom community became their "neighborhoods" of refuge.

Marsha P. Johnson (1945–1992), a Black transgender activist and Stonewall Uprising veteran, played a pivotal role in igniting the modern LGBTQ+ rights movement, her legacy continuing to inspire generations of queer and trans advocates.

THE STONEWALL UPRISING

In the early morning of June 28, 1969, police raided the Stonewall Inn, the largest, most popular gay bar in New York City at the time. The space, which was owned and operated by the New York Mafia, did not have a liquor license. The violation was the ostensible reason for the intrusion.

Police raids and accompanying harassment occurred often, and this was the second in a week. Drag queens were targets for arrest, since it was illegal to wear more than three items of clothing that did not match your gender at birth. The customers fought back, including a violent response from some Stonewall patrons—which included drag queens, trans women, "butch dykes," and people of color. There was retaliatory police brutality. Protests and clashes with the police continued for six days. This cumulative act of resistance came to be known as the Stonewall Uprising. It launched the gay rights movement as we know it today.

"Stonewall was the irreversible deliverance from accepting silence, invisibility, and victimhood," chaplain and educator Gary David Comstock wrote in *Gay Theology Without Apology*. "The project of reclaiming our ancestors would not have happened without the courage and confidence born in the post-Stonewall liberation movement."

Two iconic figures who emerged from the struggle have become part of the lexicon of LGBTQ+ history: a theologically and brilliantly funny Black trans woman named Marsha P. Johnson, and a politically radical Puerto Rican trans woman named Sylvia Rivera. While they were not present at the Stonewall Inn on the night of June 28, 1969, in the days that followed they became not only involved but also vocal proponents of gay liberation.

These two went on to create the countercultural organization Street Transvestite Action Revolutionaries (STAR). Through the group, they formed their own collective, providing housing for other trans individuals, first in an abandoned trailer and later in a burned-out building on the Lower East Side. Like Crystal LaBeija, Johnson and Rivera were creating new systems that centered a Black trans feminist political discourse that they viewed as key to their survival.

The Stonewall National Monument, photographed on June 25, 2016, a day after President Barack Obama declared it a national monument, commemorating the birthplace of the modern LGBTQ+ rights movement.

As Black women freedom fighters like Rosa Parks (1913–2005) and Congresswoman Shirley Chisholm (1924–2005) blazed trails in the late 1960s, the mothers of the House/Ball scene forged their own path, creating spaces for empowerment and self-expression.

1967

The Miss All-America Camp Beauty Pageant was held.

1968

Shirley Chisholm became the first Black woman in Congress.

1970

The first Pride celebrations took place in New York, Los Angeles, and Chicago.

1972

The Houses of LaBeija and Corey were founded.

1969

The Stonewall Uprising erupted in New York City.

THIS IS A
RAIDED
PREMISES

POLICE DEP'T.
CITY OF NEW YORK
HOWARD R. LEARY. POLICE COMMISSIONER

This "Raided Premises" sign epitomizes the police harassment of LGBTQ+ establishments before the 1969 Stonewall Uprising, underscoring the oppressive conditions that ignited the modern gay rights movement.

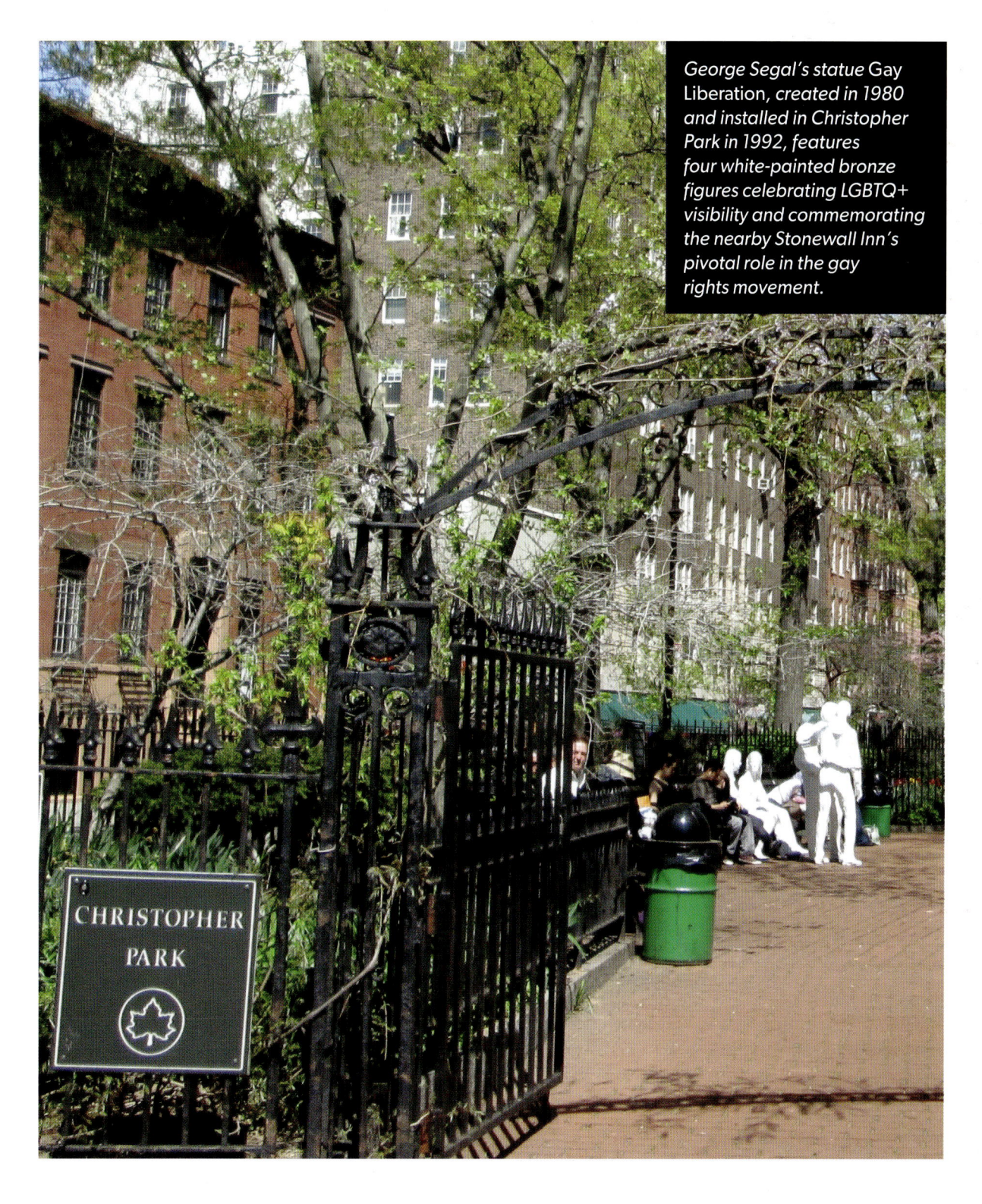

George Segal's statue Gay Liberation, *created in 1980 and installed in Christopher Park in 1992, features four white-painted bronze figures celebrating LGBTQ+ visibility and commemorating the nearby Stonewall Inn's pivotal role in the gay rights movement.*

CHRISTOPHER PARK

1973–1979
Ballroom as a Cultural Evolution

Miss Duchess La Wong, one of the greats and the only living Founding Mother of the House/Ball scene, continues to be revered as a pioneer whose influence has shaped generations of Ballroom culture since its inception in the 1960s and 1970s.

BALLROOM AS AN ART COLLECTIVE

Duchess La Wong opened her House in 1975, but she played a key role in the history of New York culture years before. In 1968, when Duchess was still walking the old drag balls, a young Larry Levan met a young Frankie Knuckles at a ball. At the time, Levan was Duchess's lover and often helped Duchess with her looks. As the story goes, it was in the process of doing this work one night that he first met Knuckles.

Their initial fortuitous meeting birthed a lifelong, near-inseparable friendship between Larry and Frankie who, as DJs, would help to create and catapult house music as an ethos of political and sexual freedom as well as a theological exaltation for the Black gay community. The musical genre became the soundtrack for the struggle of Black gay men. Its songs sat at the intersection of racial and sexual liberation for a community confronted with notions of both white supremacy and Black homophobia, particularly during the height of the AIDS crisis in the 1980s.

Levan would go on to rule the soundtracks at popular spots like the Loft and Paradise Garage, in turn influencing the airwaves of New York City. Knuckles would have an impact on the New York sound, too. But their initial point of connection was a ball. In this way, and continuing today, Ballroom and its Houses function as an art collective, connecting creatives and exposing them to one another in a way that has fostered cultural evolution.

Another art collective at the time was the Nuyorican poetry movement. As written succinctly in the article "A Brief Guide to Nuyorican Poetry" on Poets.org, that movement was "a tradition of poets, writers, and musicians whose work spoke to the social, political, and economic issues Puerto Ricans faced in New York City."

Progressive art can assist people to learn not only about the objective forces at work in the society in which they live, but also about the intensely social character of their interior lives. Ultimately, it can propel people toward social emancipation.

—Angela Davis, in *Political Affairs* magazine (1985)

Grandmaster Flash and members of his crew, including Mr. Broadway, Rahiem, LaVon, Kidd Creole, Shame, and Larry Love, pose together in this 1986 photograph, capturing a moment in hip-hop history.

HIP-HOP AS ITS DIALOGUE PARTNER

Hip-hop was the vehicle of some of this collective work. Born in the South Bronx, hip-hop traces its origins to a DJ Kool Herc party in 1973. Crews became their own networks, with B-boys, DJs, MCs, and others giving voice to the area's disenfranchised youth. Their cultural production came in the form of graffiti art and hip-hop music. Herc, Afrika Bambaataa, and Grandmaster Flash emerged as pioneers, and have been canonized as the fathers of hip-hop.

As men in the South Bronx joined their first crews, across the Harlem River Ballroom was beginning to morph. The emphasis at the early balls was on trans women and drag queens. The role that has come to be known as the femme queen was both the competitor and often the House founder. But in 1973, that changed when Erskine Christian, a gay man, walked the Models Magazine Face category. The details of the moment are lost to history, but it was a pivotal shift after which gay men could also walk at balls. Within a year, others, like Junior LaBeija and David Padilla, considered pioneers of Ballroom, were also competing.

VOGUE AS A CULTURAL PRODUCTION

In the summer of 1974, a young RR Chanel attended his first ball. Invited by Paris Dupree, though he was not a part of her House, he was allowed to sit at the Dupree table to watch the festivities with other House members. At the time, most balls were still focused on femme queens walking categories like Face, Realness, and Fashion. Chanel was infatuated and asked Dupree what it would take for him to join the House of Dupree. A trophy, Paris answered.

The next year, in 1975, Chanel walked his first category, Models Affect, a type of runway walk. The result? No trophy.

Though Butch Queen categories (for cis gay men) did exist, they were not popular in the mid-1970s. Chanel waited another year to compete, this time at Pepper LaBeija's Ball in 1976. He finally brought back a trophy to Paris, but she was still unimpressed; it was first runner-up, and she wanted a grand prize.

Later that year, Avis Pendavis, who had become a mentor to RR Chanel while teaching him how to sew, held a ball. When the Models Affect category came up, Avis, who was on the mic, called out RR.

"RR, are you a Dupree?" she asked.

"No," he responded.

"What House are you with?" she continued.

"Chanel. It's my House," he declared. That night, RR Chanel debuted his own House—he was the sole member—and that same evening, he won his first grand prize trophy.

Erskine Christian launched the House of Christian later the same year, followed by the House of Ebony from Richard Ebony in 1978, and the House of Omni from Kevin Omni in 1979. The formation of these Houses represented a shift to Ballroom collectives being formed by and through the ethos of Black gay men. The change brought in an intentional masculine energy that would have long-lasting implications surrounding patriarchy in the House/Ballroom community.

◊ ◊ ◊

Ballroom's cultural productions are numerous, but one of the most notable has been the dance form of vogue. It is within the changing landscape of Ballroom that voguing was introduced, originally called pop, dip, and spin. Its origin stories are conflicting. Some say that voguing was a pastime of gay inmates on Rikers Island. Finding inspiration in shapes and hieroglyphics, the men would compete against one another in the yard, and the moves eventually spread into the city. Others say it was created by Paris Dupree. According to that lore, one night at Footsteps, a nightclub in the East Village, Paris pulled out a copy of *Vogue* from her bag and started pointing to pages to the beat of the

Paris Dupree, founder of the House of Dupree, adorned with an Eiffel Tower hairstyle (1995/96). Her legendary Paris Is Burning Ball inspired the groundbreaking 1990 documentary film that brought Ballroom culture to mainstream attention.

Avis Pendavis (1940s–2015), a Founding Mother of House/Ball culture, and Lottie LaBeija (1930s–2003), one of the architects of the influential House of LaBeija, were pioneering figures who shaped the foundations of the Ballroom scene.

music. Others began to catch on, mimicking her in what became a battle between dancers.

Voguing's real origin is probably a blend of these two tales. Paris was a drag performer at a time when cross-dressing was illegal. It's highly likely that she had been imprisoned on Rikers Island and passed time herself playing this game of posing, before exporting it to Footsteps. Eventually, vogue caught on not only at the clubs, where it was a playful battle, but on the Ballroom floor, where it was a full-fledged competition.

Museum curator Sabel Gavaldon wrote about *A Museum of Gesture*, a 2013 exhibition at La Capella in Barcelona, Spain: "Gesture remains beyond the grasp of historians. Elusive by nature, the domain of gesture is often overlooked as a minor subject." While everyone would likely agree that bodies speak, many will be quick to point out that some bodies speak differently. Little attention is paid to the political histories and cultural struggles that punctuate the different languages of gesture, style, and body attitudes.

Vogue mended the historical damage inflicted upon the House/Ballroom community by multiple systems of oppression converging simultaneously on a community on the brink of annihilation. Just as in hip-hop, the performance became the worship. The beat became the spoken word. The stage became the pulpit. The ball became the church. The crowd became the congregation. It all together became, or rather was, God in motion. And it still is.

1973

DJ Kool Herc hosted South Bronx parties that marked the birth of hip-hop.

1973

Erskine Christian walked Models Magazine Face, the very first butch queen to walk in Ballroom.

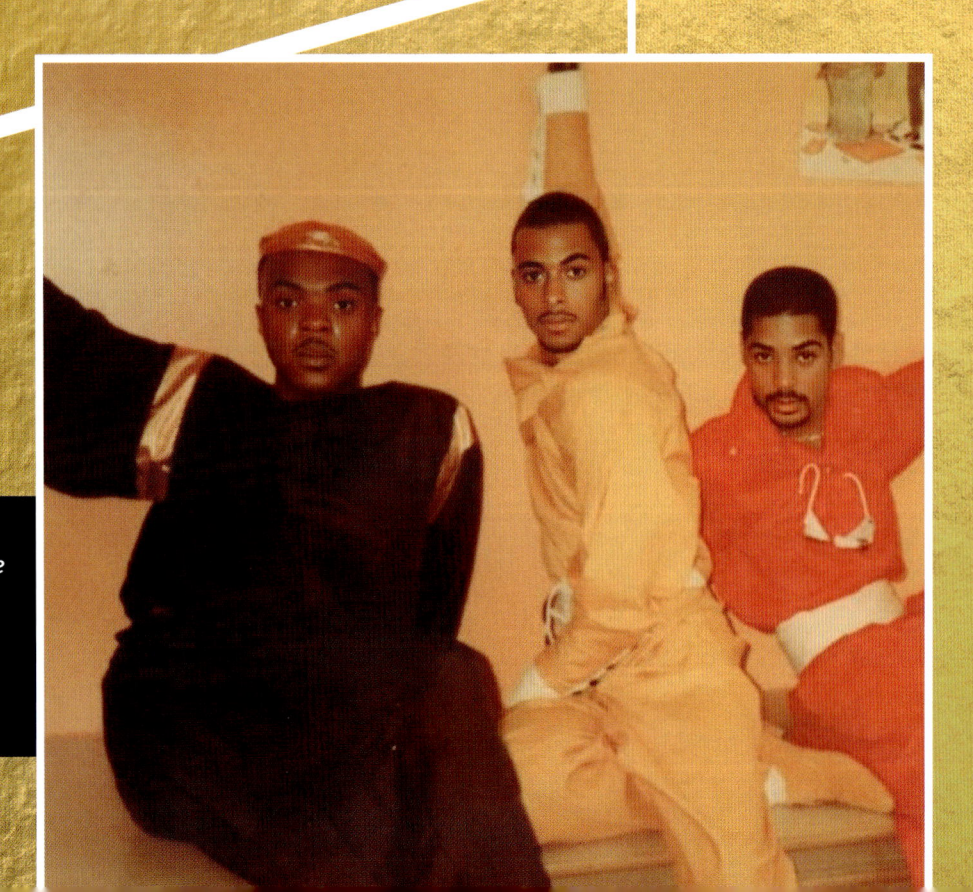

Pioneers Junior LaBeija, Michael Princess, and Erskine Christian, photographed in 1983, exemplify the early trailblazers who shaped the foundations of Ballroom culture in New York City.

1977
The House of Chanel was founded.

1979
The Houses of Omni and Pendavis were founded.

1975
The Houses of Wong and Dupree were founded.

1978
The House of Ebony was founded.

1974
The House of Dior was founded.

1980s
Empress, Princess, Duchess, Queen

Dorian Corey (1937–1993), a Founding Mother of House/Ball culture and pioneer in the Ballroom scene, shared her wisdom and experiences as a star of the landmark 1990 documentary film Paris Is Burning.

It was a decade after Crystal LaBeija put on her first House of LaBeija Ball, and people were packed around tables in a bingo hall on 125th Street in Harlem. It wasn't until just after 5 a.m. on that August day in 1982 that things really got going.

"We are going to start right now," a voice said into the microphone after introducing the judges, a few of whom were local business owners expected to know about the latest in fashion and style. "I am Pepper LaBeija. Crystal, what am I in the House?" Pepper was seated, wearing a shimmering pink striped dress and oversize earrings. After conferring with Crystal for a moment, who was seated at a table a few steps away, she continued.

"She's the empress—what does that make me? The queen? Well, I'm the queen of the House," Pepper said to applause. The Harlem Fantasy Ball Part 2, organized by Pepper and Dorian Corey, was being filmed for an hour-long documentary called *T.V. Transvestite*, showing how the scene was evolving in the 1980s.

The categories to be contested were numerous. Best-Dressed Woman called for cisgender women to come out as the foxiest lady. Nostalgia was the category for fashion that recreated styles of the past. Ethnic included over-the-top productions inspired by global cultural traditions. And Body required contestants to strip down to skimpy posing straps (or less) and strike poses. Houses like Princess, Wong, and Taylor all came out to walk. Even the Empress, Crystal LaBeija, graced the runway in a red gown with a sequined bodice and marabou boa for a section called Dreamgirls, inspired and accompanied by music from the Broadway musical that had debuted the year before.

The numerous categories became a signature of balls in the 1980s. After Paris Dupree held her first Paris Is Burning Ball in 1981, a ball she hosted well into the 1990s, a large variety of categories became the primary focus of the gatherings. As the House/Ballroom community began to establish its own legacy, categories became increasingly elaborate, expanding to accommodate the growing community.

Outside the Harlem Fantasy Ball, the contestants lived their lives in President Ronald Reagan's America. A former governor of California, the Republican had won the US presidency in a 1980

You know what a House is? I'll tell you what a House is! A House is a gay street gang. Now, where street gangs get their reward from street fighting . . . a gay House street fights at a ball. And you street fight at a ball by walking a category.

—Dorian Corey, from the documentary *Paris Is Burning* (1990)

Lady Bunny and RuPaul posed together at the Love Ball AIDS Benefit held at Roseland in New York in 1989.

landslide, ushering in an era of Reaganomics: bank deregulation that put individuals at increased risk, social program cutbacks and eliminations, and a war on drugs that had a devastating impact on communities of color. Reagan's trickle-down economic strategy didn't trickle down; it expanded the gap between the rich and the poor.

The effects of these policies had a visible impact on the balls. Where 1970s decadence included the over-the-top, flamboyant extravagance of formalwear, the 1980s brought in a focus on hip but more affordable sportswear. Balls hosted categories like Punk Rock Versus New Wave, picking up on the fashion trends of the time.

There was another, devastating threat the community had to contend with. On July 3, 1981, the *New York Times* ran a story under the headline "Rare Cancer Seen in 41 Homosexuals." Shortly afterward, this cancer was named—for a time—gay-related immune deficiency (GRID). It was also called "gay cancer," and trumpeted by some as a judgment or punishment from God on gay people. In May 1982, three months before the Harlem Fantasy Ball Part 2, Gay Men's Health Crisis (GMHC) was started as a direct result of public outcry from people like activist Larry Kramer to the federal government's lack of response to the AIDS crisis. That same year, Carl Bean founded the Unity Fellowship of Christ Church, a Black gay theological response to the crisis. In 1985 Bean would also cofound the National Minority AIDS Council, the first community organization fighting HIV and AIDS that was managed by people of color. In that same year, the Ballroom community would be hit hard.

In the summer of 1983, Kevin Omni, founder of the House of Omni, hosted a Birthday Ball on East 96th Street in New York City. The ball started at 10 p.m. instead of the typical 5 a.m. Kevin was on the mic, calling out categories and competitors—it was common for one of the organizers to emcee their own events. And there, a new House made its debut: the House of Extravaganza—later renamed the House of Xtravaganza. Founded a year earlier by Hector Valle, who was Puerto Rican, the House of Xtravaganza made history as the first majority Latinx house in a largely Black scene. Hector, the Founding Father, hadn't been in a House before, but he had already

developed a reputation in the scene for voguing, frequenting places like Paradise Garage, Tracks, and Christopher Street Pier. In a short time, the House of Xtravaganza also began to establish itself, with members like Founding Mother Angie Xtravaganza and Carmen Xtravaganza. In 1988, Carmen was featured on the cover of the *Village Voice* in one of the first major mainstream press stories about the Ballroom scene. The story was headlined "Venus Envy: The Drag Balls of Harlem."

Hector was not able to witness the growth and power of his House of Xtravaganza, which would eventually become one of the most well-known Ballroom Houses. In 1985, he became one of the first of many members of the community who died from AIDS-related complications. His death was symbolic of many things that defined the 1980s—a time of systemic homophobia that manifested itself as benign neglect for bodies deemed not worthy of care and not valuable enough to save.

The devastation of AIDS and the destructiveness of Reagan-omics was joined by the crack epidemic. (Crack is a cheap, highly addictive form of cooked cocaine that began to flood cities like New York, Miami, Los Angeles, Chicago, and Philadelphia.) Punish-ment for possession of crack—a crime that largely affected inner cities where Black people and other people of color lived—was so much more severe than punishment for possession of powder cocaine, which was more often a crime in white suburban areas, that the difference was referred to as 100:1.

The cumulative impact of these three crises hit the Ball-room community hard. Yet efforts made to address them often excluded the Ballroom community. Organizations like GMHC underserved Black communities. In response, Black, Indigenous, and People of Color (BIPOC) gay organizations began forming as a political response. These included the National Minority AIDS Council, ADODI, and Gay Men of African Descent. The Black LGBTIQ+ literary group Other Countries formed to write about and articulate the situation Black gay men confronted, at the intersection of race and sexuality, with the AIDS crisis. But these organizations that stepped up to fill the gaps did not include the House/Ballroom community in their organizational efforts, due

Supermodels Naomi Campbell and Marpessa Hennink, wearing Thierry Mugler designs, attended the Love Ball AIDS benefit at the Roseland Ballroom in New York City in May 1989.

to a classism in the Black LGBTQ+ community that historically saw the House/Ball community as less than—less important, and less worthy of being taken care of and saved.

Motivated by a dual response of survival and nihilism, the Ballroom community continued to expand. In 1986, Eric Christian Bazaar moved to Washington, DC, and, along with Lowell Thomas Hickman, founded the House of Khan. It was the first House founded in the nation's capital, and it launched the scene there. It was also the first House that Eric helped found. He would go on to create more Houses than anyone in Ballroom history, emerging as one of the scene's great community organizers and infrastructure developers.

◊ ◊ ◊

Ballroom's growth in the 1980s included cultural expansion and ways to share its celebration with the wider public. Jody Watley made history when she released the song and music video for "Friends," the second single off her sophomore album, *Larger than Life*. The song peaked at no. 3 on the Hot Black Singles chart and became the first entry featuring a rapper (Eric B. and Rakim) and a singer to make it to the Hot 100 charts, where it topped out at no. 9. The music video landed on Donnie Simpson's *Video Soul Top-20 Countdown* and played on BET and MTV. With a Club Couture concept, it featured Watley wearing Jean Paul Gaultier as B-boys, drag queens, and others danced around her. Mock judges held up placards with tens as Mohammed Omni vogued the Old Way (known as pop, dip, and spin) and Derrick Pendavis Xtravaganza vogued the New Way (which was more gymnastic and included double-jointed stretches of the arms and legs, splits, and extremely difficult poses). "Friends" became the first music video to spotlight the Ballroom community and voguing, presenting the dance form in the context where it was often seen during that decade—the clubs. Mohammed and Derrick also danced in silhouette in Queen Latifah's "Come into My House," alongside Willi Ninja. The Ballroom scene was entering the mainstream in a whole new way.

NAMES PROJECT AIDS MEMORIAL QUILT

In 1987, as Larry Kramer founded the AIDS Coalition to Unleash Power (ACT UP) to demand swifter government action on HIV prevention and AIDS care, the NAMES Project AIDS Memorial Quilt was also initiated. Created as a visual legacy, the quilt commemorates lives lost to AIDS-related causes, including many from the Ballroom community. Upon completion, it featured nearly 50,000 panels honoring over 110,000 individuals.

Over the next few years, there was an explosion of visibility. Derrick Xtravaganza and Willi Ninja (who had launched his Asian-inspired House of Ninja in 1982) appeared in Marlon Riggs's 1989 documentary about gay Black men, *Tongues Untied*, voguing on the piers. Willi Ninja also appeared in Malcolm McLaren's "Deep in Vogue" music video, which was sampled from an early cut of the in-progress documentary *Paris Is Burning*. And in 1989, the first Love Ball was organized at Roseland by nightlife impresario Susanne Bartsch and *Details* magazine editor Annie Flanders. Fashion designers Donna Karan and Thierry Mugler, David Byrne of Talking Heads, and the model Iman were judges. Pepper LaBeija of the House of LaBeija, editor of *Vogue* Anna Wintour, and *New York Times* photographer Bill Cunningham were among those who attended. Love Ball raised $400,000 for the Design Industries Foundation Fighting AIDS (DIFFA), the most money the fashion industry had ever raised for the epidemic.

This progress came despite the oppressive forces that seemed crushing to those who made up the House/Ball community. The Ballroom scene, and those in it, were being told they didn't deserve to exist, yet they not only lived but flourished, piercing the mainstream and expanding their reach. Months after the Love Ball, Michael Gaskins of the House of Onyx put on the Onyx Ball in Philadelphia at a YWCA on Chestnut Street. No longer would residents of the city, like Taffy and Nate Jadu, have to travel to New York to attend a ball. This ball, and the Houses of Jadu, Excellence, and Onyx, launched the Philadelphia Ballroom scene—setting the stage for the next decade, which would come to be known as Ballroom's Golden Age.

OTHER HOUSES FORMED IN THE 1980S

◊ House of Africa
◊ House of St. Laurent
◊ House of Ovahness
◊ House of Montana
◊ House of Princess
◊ House of Adonis
◊ House of Fields
◊ House of Milan
◊ House of Miyake-Mugler
◊ House of Magnifique
◊ House of Lamay
◊ House of Leviticus (New Jersey)
◊ House of Grace (New Jersey)
◊ House of Khan (the first house of Washington, DC)
◊ House of Jadu (the first house of Philadelphia)

Tracey Africa Norman, a pioneering Black transgender supermodel from the legendary House of Africa, graced the pages of Vogue Italia *in 1977, breaking barriers as a Clairol cosmetics beauty and establishing herself as a trailblazer in both the fashion world and Ballroom community.*

Pepper LaBeija (1948–2003), one of the greats in Ballroom culture, was a Founding Mother of the House/Ball scene who left an indelible mark on the community through her leadership and artistry.

A moment between two influential figures in the scene: Willi Ninja (1961–2006), the renowned vogue master, poses with Luna Luis Ortiz (born 1972), then known as Luna Luis Blahnik, an extraordinary photographer and future Ballroom Hall of Fame Icon.

Paris Dupree (c. 1950–2011), our revered Founding Mother, embodied the monumental legacy of Ballroom culture, shaping its history and leaving an indelible mark on generations to come.

Willi Ninja (1961–2006) the legendary voguer, leading a group in a dynamic performance, his movements telling the story of vogue and exemplifying why he was known as the "Grandfather of Vogue."

1990s
Ballroom in the Spotlight

Jose Xtravaganza, a Ballroom Icon, executed a stunning dip at the War Ball, hosted by legends David Ian Xtravaganza and Roger Milan at the renowned Sound Factory on 27th Street in New York City.

A young Afro-Nuyorican gay man named Felix Rodriguez sat in a movie theater, witnessing a rare and powerful moment on the screen: people who reflected not only his racial and ethnic identity but, equally as significant, his sexual identity. The film was, of course, *Paris Is Burning*, and the filmmaker was a white queer woman named Jennie Livingston. As Felix watched, surrounded by a predominantly white audience, he sensed an uncomfortable disconnect. Their laughter at certain moments felt inappropriate, misplaced. This experience sparked an epiphany: the Ballroom community needed to document itself, to tell its own stories through its own lens.

Inspired, Felix began filming balls almost immediately, starting with the Pendavis Ball in the spring of 1992. He organized screenings of his films in his living room, seeking input from community members. This grassroots approach would become a crucial counterpoint to external representations of Ballroom culture. Felix's efforts (which continue to this day with his ongoing documentary, *My Ballroom Story*) exemplify the Ballroom community's efforts throughout the 1990s to control its own narrative and cultural productions in the face of growing mainstream attention.

As the 1990s dawned, the House/Ball culture was poised for explosive growth. It had already spread beyond its New York City origins to Washington, DC, in 1986 and Philadelphia in 1989. In 1990, it reached its fourth city: Baltimore. This geographic expansion set the stage for a decade that would see Ballroom culture reach unprecedented heights of visibility and influence.

The same year, Madonna released "Vogue." She had situated herself alongside Janet Jackson and Whitney Houston as part of a trio of pop queens. "Vogue" was about the emblematic dance of the House/Ball community. The video featured two of the most popular and talented voguers from the community—Luis Xtravaganza Camacho and Jose Xtravaganza. The following year, Madonna's documentary *Truth or Dare* showcased Luis and Jose again, sharing elements of Ballroom culture with a global audience. While this brought mainstream attention to voguing, it also raised questions about cultural appropriation that would persist throughout the decade.

History isn't what happened, but a story of what happened. And there are always different versions, different stories, about the same events. . . . History is just one tool to shape our understanding of our world. And every tool is a weapon if you hold it right.

—History Is a Weapon website

Carmen St. Laurent Xtravaganza, the Imperial Latina Goddess, dazzles at the House of Pendavis Ball in New York City's Red Zone, epitomizing Ballroom glamour and prestige.

As Ballroom gained visibility, it was also grappling with the devastating impact of the HIV/AIDS crisis. In 1991, tensions surrounding the epidemic came to a head when ACT UP organizer Robert Rafsky confronted presidential candidate Bill Clinton at a rally, bringing the crisis into the national political spotlight. The Ballroom community, which was heavily affected by AIDS, responded with initiatives like the Love Ball 2 at the Roseland Ballroom in New York, benefiting the Design Industries Foundation Fighting AIDS.

ICONIC BALLS

Throughout the decade, a series of iconic balls and moments shaped the scene.

1992: The Xtravaganza/Milan Alphabet Ball at Tracks nightclub in Manhattan, a collaboration between two leading New York Houses, showcased the growing sophistication and cooperation within the community.

1993: The Bazaar Ball at the Marc Ballroom featured a heated Femme Queen Face category with legendary competitors. Tracey Africa Norman, the first Black transgender supermodel, graced the floor alongside Heavenly Angel Octavia St. Laurent and the dark and lovely Moldavia LaBeija. Alyssa St. Claire, Keisha Revlon Ebony, and Brenda Milan also competed. But it was Danielle Revlon who stole the show, entering to thunderous applause in a short haircut, tight black dress, and white pearls, and claiming the grand prize.

1993: The first NYC Awards Ball, thrown by Jack and Andre Mizrahi, recognized excellence across all Ballroom categories, institutionalizing the community's system of merit and achievement.

1993: In Philadelphia, the first **Polo Ball**, organized by Founder Kenny Polo, was held at the Nile Club, marking the city's growing importance in the Ballroom scene.

1995: Alvernian Prestige and Otis Gigli held the first **Unity Ball** in Philadelphia at the Nile Club. This ball inaugurated a series of collaborations between Prestige and other Ballroom personalities, fostering unity within the community.

BALLS WITH A MISSION

As the Ballroom scene expanded, it also evolved to address the pressing issue of HIV/AIDS. This led to the creation of balls specifically designed as HIV prevention and community organizing initiatives:

1991/1992: The Fire Ball in Newark, New Jersey, was part of Project Fire, which aimed to organize the House/Ball community in Newark and surrounding areas while addressing HIV prevention. Led by James Credle and Don Ransom, with support from House/Ball leaders like William and Bernie from the House of Jourdan, and Angel and Patrick from the House of Richards, it became a model for ways to use a ball as a tool for public health and community organizing.

1994: The Latex Ball in New York City, organized by GMHC's Latex Project, became a model for combining HIV prevention with Ballroom competition. The late great Arbert Santana, the first Mother of the House of Latex, integrated HIV prevention efforts directly into the competitive structure of Ballroom, as the emcee provided HIV prevention information during the ball. The 1994 Latex Ball was the first collective effort in the House/Ball community to work through a community organization. In the same year, the House of Latex produced a public service announcement, "Having Fun Never Has to End."

1997: The Legendary Crystal Ball in Philadelphia, created by Odu Adamu (known in the community as Kwame Ferragamo) and the Colours Organization, continuing the collective intravention, addressed rising HIV rates in the local House/Ball community. As a House/Ball walker and leader, Odu brought a unique perspective to this initiative. He "created a template for critically engaging Black organizations that in turn bolster the House and Ballroom communities across the United States" (from a 2023 interview on the website The Thing Beneath the Thing).

These initiatives marked a meaningful change in how the Ballroom community responded to the AIDS crisis. It was now using its own cultural forms as tools for education and prevention.

The enraptured audience at the 2022 Latex Ball, akin to a church congregation, watches, praises, claps, and cheers, their fervent energy elevating the vogue performers to near-divine status.

A TIME OF CHANGE

In 1996, the Ballroom scene made a significant move southward as Anthony Poultry formed the House of Escada at Morehouse College in Atlanta. The House of Escada Winter Solstice Ball was the first ever in Atlanta. These events quickly established Atlanta as the second-largest Ballroom scene, nurturing homegrown talent and attracting New York transplants like Makuda Chanel, Stewart Ebony, June St. Claire, and Andre Mizrahi. Atlanta developed some of the best performers in Ballroom history, including CoCo Chanel, who upset New York's 1997 Revlon Ball in the Femme Queen Face category.

The Atlanta scene also gave rise to a trio of Femme Queens—Raquell Lord Balenciaga, Stasha Sanchez Garcon, and Jasmine Bonet Milan—who straddled three different communities: the Trans Pageant Circuit, the Club Lip Sync Show Circuit, and the House/Ball community. Their success across three different arenas—unusual at the time—highlighted the growing influence and versatility of Ballroom performers.

In 1998, Pepper LaBeija held her last ball; it was at the Brooklyn YWCA on Atlantic Avenue. The Femme Queen Face category that night was fire! Dominique Jackson, years before her *Pose* fame, strutted like Dominique Deveraux from *Dynasty*. Tanya Prada, tall and curvy with her signature bald head, assumed her usual bold stance. Ayana Khan, from DC, beautiful and inspiring, stormed through. But it was Renee Karan who stole the show! She sashayed in, all attitude in a black dress and heels, dramatically revealing her face by snatching off her shades. When she raised her hand to the sky, the crowd went wild! What a night to remember! Little did they know, this would be Pepper's final ball. Her health was declining, and she passed away from complications of diabetes five years later.

The 1990s weren't all glitz and glamour. There was heartbreak, too. Some of Ballroom's fiercest Founding Mothers passed away, which hit the community hard. In 1993, Dorian Corey, Founding Mother of the House of Corey and a pillar of the House/Ball community, passed away due to AIDS complications. The

Pepper LaBeija (1948–2003), one of the revered Founding Mothers of the Ballroom scene, held her final ball in 1998 at the YWCA on Atlantic Avenue in Brooklyn.

Evie Pendavis Milan, a notable figure in the Ballroom community, was captured in this photograph taken around 1999.

discovery of the mummified body of Robert Worley (who had disappeared in 1968) in her apartment added a mysterious postscript to her legendary status.

In the same year, the House/Ball community said goodbye to Angie, the heart and soul of the House of Xtravaganza. New York's Ballroom scene was never the same. And in 1995, Avis Pendavis, Founding Mother of the House of Pendavis and another cornerstone of the House/Ball community, passed away. These losses cut deep. But they also inspired the community to survive and thrive, to keep pushing, keep living.

As the 1990s came to a close, two significant events pointed toward the future of Ballroom. In February 1999, Andre Mizrahi vogued on *Showtime at the Apollo*, winning the first week but facing backlash in the second as the audience realized the dance had its origins in the gay community. This moment highlighted both the growing mainstream appeal of voguing and the persistent prejudices the community faced. And at Eric Christian Bazaar's Ball in Brooklyn, the House of Ebony introduced and announced Sinia as the new Overall Mother. The ball went into an uproar. In the 1990s Sinia had won many competitions in Femme Queen Performance, voguing her way into becoming one of the gold standards for the category—and doing it with so much sex appeal that she was the new reigning Empress of Sex. With her being gifted the title of Overall Mother of the House of Ebony, which was the largest House at the time, it was a certainty that the 2000s would be defined by legions of girls who would reflect her powerful influence. Some were developed by Sinia; some were her chosen daughters (ones who helped her manage the House). Many would come from different geographical regions, as Ballroom blew up across the United States and outside of it. Both Sinia and Andre Mizrahi would become the ideal, both in their artistry and their stature.

The Ballroom scene exploded with growth, visibility, and cultural impact in the 1990s. It spread to new cities, shook up mainstream pop culture, and created new ways to fight the AIDS crisis. Even with all the losses and challenges, the community's strength and creativity blazed through, setting up the next millennium to be even fiercer.

Ballroom stepped into the spotlight like never before. From Madonna's "Vogue" to *Paris Is Burning*, from HIV prevention balls to new Houses popping up across the country, it was everywhere. As the world started watching, Ballroom kept innovating—new categories, new stars, new ways to use balls to change the game. Through growth, loss, and transformation, the Ballroom community came into its own, faced down challenges nobody saw coming, and emerged stronger and more visible than ever. What was built in the 1990s would shape the culture for decades to come, underscoring the power of the community, the importance of telling one's own stories, and the legacy of those who came before.

Ballroom didn't just survive the 1990s, it thrived. And, while staying true to itself, it left its mark on American culture. Ballroom carries its spirit of innovation, resistance, and celebration into the future. The category is . . . Legendary!

The legacy of the Latex Ball continued with Thee Sade and Renaldo Maurice, Overall Father of the House of Alpha Omega and Alvin Ailey dancer, bridging Ballroom culture with broader artistic communities.

Slim Rodriguez, a star of the TV series Pose, *posed outside the Latex Ball with a friend, capturing a moment that bridges the fictional portrayal of Ballroom culture with its real-life contemporary scene.*

2000–2008

Ballroom as a Radical Pedagogy

A House of Milan member commanded the Best Dressed category at the final POCC Ball at Webster Hall in New York City. America's second-largest Ballroom gathering, this POCC Ball was a landmark HIV awareness event, drawing 2,800 attendees.

In 2002, I started what would become the second-largest free annual ball in the Ballroom scene, surpassed only by the Latex Ball sponsored by GMHC. At the time I was the director of services at People of Color in Crisis (POCC), a Brooklyn-based organization doing radical and effective work around HIV prevention and providing care that targeted Black gay men. The ball was a part of the NYC Black Pride lineup of events that year, as POCC joined with the organizers by becoming a financial sponsor.

At the time, organizers of Black Pride celebrations across the country often viewed the Ballroom community with disdain. To many, Ballroom represented all the worst stereotypes of what it meant to be Black and gay, so they shunned any association. This didn't stop Ballroom Houses from hosting balls concurrently with Pride events and in the same cities. But balls were not official, sanctioned Black Pride events. Until the POCC Ball.

The Legends Ball in 2000, along with both the Arbert Santana Latex Evisu's Latex Ball in New York and the Crystal Ball organized by Odu Adamu in Philadelphia, helped shape the idea for the POCC Ball—a ball that was community-driven, that was an HIV prevention ball, and that was free to the public (like both the Latex and Crystal Balls), while also expanding on the gravitas of the Legends Ball. Achieving these goals meant securing a venue where every attendee would immediately feel worthy; a space that evoked a sense of reverence was the primary objective. A few months earlier, Jack Mizrahi Gorgeous Gucci had hosted the 10th anniversary NYC Awards Ball at the World, a massive restaurant, nightclub, and retail store in Times Square. The space hosted events for World Wrestling Entertainment (WWE), where Jack worked at the time, and its management was already aware of the Ballroom scene. This was exactly the place needed.

To reinforce the concept that Ballroom and its innovators had created something meaningful and important, I honored influential figures in the scene by mentioning them in the category descriptions. This reinforced notions of legacy and reverence, while also getting the community engaged and excited.

This ball was what scholar and professor Dr. Marlon Bailey (who wrote the first PhD dissertation looking at the House/Ball

The story of Ballroom in the 2000s is personal to the experiences of the author (shown below), which he relates here.

community, which later became the book *Butch Queens Up in Pumps)* calls an intravention. This is the fifth tenet: Ballroom as a radical pedagogy. This meant that in addition to giving Ballroom the platform it deserved, the event was ultimately about mass mobilized outreach around a still-growing epidemic; just a year earlier an HIV prevalence report done by the Epidemiology and Evaluation Section of the San Francisco Department of Public Health concluded, "High HIV prevalence suggests an urgent need for risk reduction interventions for male-to-female trans-gender persons." And in a December 2001 report, the Joint United Nations Programme on HIV/AIDS (UNAIDS) warned, "The prospect of larger HIV/AIDS epidemics cannot be ruled out if widespread public complacency is not addressed," as rates of condomless sex and sexually transmitted infections rose. It was imperative that we brought in as many members of the community as possible, not only to alert them to POCC's services, but to impress upon them the stakes of the epidemic.

To usher the community into the space, we asked Kwame Ferragamo, who is a Yoruba priest, to open the ball with a spiritual ritual. He had each of the thirteen judges walk in honor of someone we had lost over the years. Kwame walked in honor of his kinship son Otis Romeo Gigli, who had been murdered in Philadelphia; Junior LaBeija walked in honor of New York DJ Larry Levan; RR Chanel graced us in honor of Eric Christian Bazaar; Selvin Mizrahi performed in honor of Mother Avis Pendavis; and Arbert Santana glided down the runway in honor of Ronnie Moschino. This ritual would prove to be so effective in gathering the mood in a ball and uniting the spirit of the community that it was repeated the following year at the 2003 POCC Ball at the Roxy in Manhattan, and then twenty years later in Amsterdam by Zelda Fitzgerald from the House of Ninja when she coproduced the Black Pride Ball Amsterdam in 2022. Balls as radical pedagogies became increasingly common in the 2000s.

During this decade, the apparatus of the House/Ballroom community expanded alongside technology. With easily accessible internet, the community built out an entire media arm with forums like Walk4MeWednesdays, created by Juan La Perla Ballroom

Ballroom culture has spread beyond America, with events like the Black Pride Ball in Amsterdam showcasing the global reach and influence of the scene.

Scene Radio; various Yahoo groups; as well as physical media like *Ballroom Rockstar* magazine. The introduction of YouTube in 2005 gave us a much faster, digitized way of disseminating videos (previously done by passing around VHS tapes and DVDs) that reached far beyond the community.

Members of the scene were also injecting themselves into the mainstream. Benny Ninja appeared as a posing instructor on *America's Next Top Model* from 2007 through 2009. Isis King Tsunami, a member of the Ballroom scene for several years, competed on the show in 2008 as the first trans woman to do so. And the next year, stylist and Ballroom Icon from the House of Milan Eric Archibald appeared on the MTV reality show *Styl'd*.

Major media outlets began to show renewed interest. In 2005, for example, the *New York Times* ran a feature, "Still Striking a Pose," about Ballroom and voguing on the occasion of the 25th anniversary of the House of Ultra Omni. This intrigue coalesced around a more athletic and aggressive style of voguing known as the dramatic style of vogue femme, originated by Ashley Icon and Mystery Dior in the 1990s. Followers of this style, including Kassandra Ebony, Pony Zion, Leiomy Maldonado, and Alloura Jourdan Zion, stepped into their own. They brought moves like the *macaella*—a dip that was named in 1995; it involves slamming into the floor quickly and athletically instead of slowly and with more poise. The 360 dip—originated by Leiomy—involves starting horizontally and executing a complete spin before landing back into a dip with your leg outstretched.

But amid this joyful explosion, the community still grappled with rising rates of new HIV infections, drug use, and deaths. So, as with the POCC Ball, and the Latex Ball and Crystal Balls before it, we leaned into organizing.

In 2006, ABC aired a prime-time special, *Oprah Winfrey's Legends Ball*, chronicling Oprah's three-day celebration in May 2005 honoring twenty-five African American women. The weekend included a Legends Luncheon, a formal white-tie ball, and a gospel brunch. Watching the footage together on a three-way call with Bernie Jourdan and Derek Prada-Ebony, we were overcome with tears. We yearned to recreate Ballroom's own version of the Legends Lunch. A few days later, Mike Haynes Ebony (cofounder of Ballroom, We Care (BWC) and known in the community as Uncle Mike) came into the offices of POCC in Park Slope, Brooklyn, with the same exact idea.

That project materialized in 2007 as Ballstar Weekend. It was both an initiative of POCC and a response to the mounting number of deaths over a six-month period from late December 2006 through June 2007, including Lorenzo Mugler, Mystery Dior, Jamel Morton, Javonta Miyake-Mugler, Ray Manolo Blahnik, and Leon Mugler Khan. That trend would be just the beginning, escalating over the next decade.

Derek found the vendor that created and supplied the original stars on the Hollywood Walk of Fame and had them create stars for

Octavia St. Laurent, a heavenly angel of the Ballroom scene, and supermodel Naomi Campbell, a runway master, came together at the Tanqueray Ball Aids Benefit in November 1989 at the Sound Factory.

community members such as David Padilla Xtravaganza Ultima, RR Chanel, Octavia St. Laurent, Tracey Africa Norman, Robbie St. Laurent, Junior LaBeija, Michael Dupree, and Michael Princess. Derek, Bernie, Uncle Mike, and I organized three days of events. On Thursday we held a mini-ball where we provided HIV testing, on Friday we hosted a club night for moments of community, and on Saturday we hosted the Legends Brunch at the Brooklyn Marriott, followed by a mini-conference. At the all-white-attire brunch, Jack Mizrahi Gorgeous Gucci moved the room to tears reading Pearl Cleage's poem "We Speak Your Names," which she wrote for Oprah's event and that celebrates the achievements of women who have inspired her as a Black woman. And that Sunday, the weekend was capped off with the POCC Ball held at Manhattan's Webster Hall.

◊◊◊

Few occurrences embody the intersection of the public fervor around the Ballroom community, the politics of visibility, and the effort to care for our own as perfectly as Vogue Evolution. It's the first choreographed professional LGBTQ+ dance group built around voguing. Founded by my kinship son Pony Zion in 2008, it began as an intravention. While working at POCC, Pony envisioned the dance troupe as a magnet for young people to come into our facilities and take advantage of our services. He and Dashaun Wesley Basquiat recruited some of the principal voguers of the time, including Kassandra Ebony, Stanley Milan, Kristina Tsunami, Tamara Prodigy, and Leiomy Maldonado, to spark more interest.

At the same time, members of the community were watching people in the mainstream appropriate vogue styles but never give credit to the originators. To reclaim the narrative, Vogue Evolution auditioned and got booked for the 2009 season of *America's Best Dance Crew*. Vogue Evolution—Pony, Dashaun, Leiomy, Malechi Williams, and Prince Miyake-Mugler—evolved from a radical pedagogy project into a global sensation.

The team made it through five episodes, meshing vogue with Bollywood, martial arts, and the early 2000s viral dance craze "Halle Berry." In Episode 2, after executing a Beyoncé-inspired

This decade, the Ballroom community mourned the loss of Pepper LaBeija (1948–2003), following the earlier passing of her sister-in-arms, Dorian Corey (1937–1993), both among the original trailblazers who shaped the foundation of the scene.

number to her hit "Crazy in Love," choreographer and judge Shane Sparks spoke to the team.

"Leiomy, ever since the show aired, every day somebody has been saying your name," he began. "They been like, 'I can't believe she's on this show.' They been tripping because you're like a god in New York or the underworld or wherever you're from. And I'm tripping because now I see why. You ripped the stage tonight."

Leiomy was the first trans woman contestant, and the comment highlighted the team's role as cultural ambassadors doing vital work as freedom fighters of representation, enduring homophobic and transphobic comments from the stage week after week. In one instance, for example, Lil Mama, a judge for the show, offered a critique of Leiomy that was viewed as offensive and disrespectful by the trans community, the Ballroom community, and the larger LGBTQ+ community. She later walked back her comments in a press release issued by GLAAD, although many felt that MTV should have forced her to apologize on the air.

But far from the national attention, the balls that gave birth to Vogue Evolution were again morphing. A year earlier, a Manhattan church basement was the setting for a pivotal moment. On an elevated runway, two men held open oversize printed fans, concealing the person behind them. As music played, they stepped aside to reveal Shannon Balenciaga, then in the House of Khan, in a floral silk gown and matching scarf. As she began to move to the music, Jack Mizrahi Gorgeous Gucci's voice rang out on the mic.

"One chop!" She was cut from the category. Undaunted, Shannon kept on, removing the platinum blond wig to reveal a short bob, bangs included. The room erupted in adulation as she pumped down the runway, tossing her hair. Despite shouts of "She is sitting" (as in "sitting just right"), the chop stood.

The category was Femme Queen Face and the prize was $5,000, one of the first large grand prizes for a nonperformance category. (Raquell Lord Balenciaga was the first winner in 2004 at the House of Ebony's Making of a Legend Ball in Atlanta. She was dramatically wheeled out onto the runway in a covered cage to a Sade mix.) There were many chops that night at the Evisu Loves

NY Ball; Tempress Chanel and Dee Dee Lanvin, who was then in the House of Balenciaga, were among them. It was Amiyah Scott, then the Overall Mother of the House of Mizrahi, who took home the money.

In Femme Queen Face, the participant shows off their face as if they are on a magazine photo shoot. The point is to highlight their movement as they walk down the runway, how they use their hands, and how they angle their face to their best advantage. It's not a dance category.

On Labor Day 2009, many of those same competitors were back, walking another Femme Queen Face category in Atlanta, at a ball hosted by the House of Ebony. This time the prize was $7,500—the largest single-person grand prize in Ballroom history. Raquell wore a shimmering gown, oversize earrings, and long-haired fur sleeves. Tempress, in her debut as the Overall Mother of the House of Allure, wore a blue, green, and black feathered gown and a jewel-studded statement necklace. Pink-lipped Amiyah sported blond wavy hair and a crystal-studded gown. But it was Dee Dee in a short pixie cut, debuting as the House of International Chanel's Overall Mother, who claimed the top prize. This night launched her reign and set a new standard for high-production balls with hefty grand prizes that would define the next decade, cementing Femme Queen Face as one of Ballroom's premiere categories.

Leiomy Maldonado, known as the "Wonder Woman of Vogue," stars in HBO Max's Legendary, showcasing her iconic talent and bringing mainstream attention to the art of voguing and Ballroom culture.

The signature vogue pose, with its defining arched back, tells the story of a magnificent people through its elegant layout, as captured at the Ninja Ball 2021 in Denver, Colorado.

Drag stars Juicy (left) and Ruby (right) at Denver's fourth annual Black Fantasy Ball 2022, a cornerstone event by Colorado Black LGBTQ+ Pride and House of LaBeija, showcasing the city's emerging Ballroom scene.

At the Latex Ball 2022, two alluring contestants showcased the art of dressing sexy, with their carefully crafted appearances competing for the judges' approval in a vivid display of Ballroom fashion and presentation.

THE KIKI SCENE

Family conflict over sexuality or gender identification leads to a high level of homelessness among teens and young adults who identify as LGBTQ+, especially among Black and Latinx youth. Understanding the need for a community inspired by traditional Ballroom but specially focused on young people, activists, led by Aisha Diori (also known as Icon Aisha Prodigy), a Black cisgender queer woman working at the Gay Men's Health Crisis, formed the Kiki scene in the early 2000s. The intention of this intravention was to create harmony and community with young people in the LGBTQ+ community.

Kiki has evolved into a thriving scene through the work of many, including Thierry Mizrahi, who worked at the Hetrick-Martin Institute, a community-based organization that provides comprehensive services to LGBTQ+ youth in New York City. In 2005, they launched the first annual HMI Kiki Awards Ball in New York City.

As the Kiki scene grew, leaders began to emerge. They started working with public health community-based organizations such as Housing Works, POCC, The Gay and Lesbian Center, and Gay Men of African Descent. This led to greater engagement with young people between the ages of 16 to 24, who are disproportionately affected by homelessness, violence, and high rates of HIV.

As in the wider Ballroom community, there are organized Kiki Houses, including the first, the House of Sequoia (formed in 2004), along with the House of Snapple, House of Xpradaganza, House of Old Navy, House of Pink Lady, and many more.

The Kiki scene, a youth-oriented offshoot of mainstream Ballroom culture, empowers LGBTQ+ youth through smaller, more accessible events that blend competition, mentorship, and community building, as illustrated in this vibrant collection of images.

The Kiki community has expanded beyond New York to Philadelphia, Atlanta, Chicago, Detroit, Dallas, and Los Angeles, often reaching out to mobilize community-based organizations such as Abounding Prosperity in Dallas and REACH LA in Los Angeles. Global expansion extends to Toronto, Montreal, Paris, London, and beyond.

In November 2023, the Iconic Kiki House of Juicy Couture held their 15th anniversary Kiki ball, at the Amazura Concert Hall in Queens, New York. The House of Juicy Couture is considered, both by the overall Ballroom community and within the Kiki scene, as the top tier and largest Kiki house. It was founded by the legendary Icon Courtney Juicy, who is also the East Coast Mother of main scene House of Balenciaga. With her phenomenal talent as a community organizer, and deep roots in the New York City dance scene, the expectation and the hype for the ball was high. And as expected, the ball delivered. It had the largest draw of any Kiki ball in history, with more than 1,500 people in attendance. This beats the records of most major balls in the country, making a statement that the KiKi scene is here to stay.

In many ways, Kiki represents the future of Ballroom. The Kiki House of Juicy Couture is a powerhouse that can compete with any main scene Ballroom houses. When it first broke onto the scene in the early 2000s, Kiki was often considered a kind of "junior varsity," but at the end of the final season of *Legendary* in 2022, the Kiki House of Juicy Couture were the winners, beating out all the main scene Ballroom houses. This not only expanded the star power of the Kiki House of Juicy Couture, but it led to a further expansion of the Kiki scene globally.

Kiki makes more spaces of freedom for LGBTQ+ youth around the world. As it establishes a future path for many in the Ballroom community, it is already adding to the legacy of Ballroom.

"I've witnessed firsthand the transformative power of this once-underground culture," says Icon Aisha Prodigy. "Ballroom isn't just about competition and extravagant costumes, vogue, and competition; it's a safe haven, a family."

The icons and legends of the Kiki scene, a youth-oriented offshoot of the mainstream Ballroom community, preside as judges at a Kiki ball, fostering the next generation of Ballroom performers and culture.

2009–2016
Making an Impact

The Ovahness Ball, a vibrant celebration of Ballroom culture, was organized by REACH LA under the guidance of Mother Martha Chono-Helsley, showcasing the community's talent and creativity.

America's Best Dance Crew (which aired on MTV from 2008 to 2015) introduced a new generation to the art form of voguing, and they were ready to dive deeper on YouTube. Now, when Leiomy Maldonado did her 360 dip or audiences found that they were fans of Prince Miyake-Mugler's softer, more sensual style, they had a library of videos to immerse themselves in.

YouTube also gave the world unparalleled access to balls. Channels like Ballroom Throwbacks Television (founded in 2009, it remains the largest free and publicly available archive of documentary footage from the scene) gave people who had never attended a ball the opportunity to engage with Ballroom and learn about the categories and the major players.

By 2011, international dance competitions like the Streetstar Festival in Stockholm, Sweden, began to include voguing in their mix. Benny Ninja, who had been voguing since 1990 and was a fixture in the underground ball scene, was on the panel of judges for a set of voguing battles that included Lasseindra Ninja. Lasseindra was based in Paris at the time, where she, along with Steffie Mizrahi, had begun organizing a Ballroom scene. Their efforts would bear fruit when Paris chapters of the Houses of Mizrahi and Ninja opened in 2013.

Streetstar's introduction of voguing followed Germany's Funkin'Stylez, founded in 2004 in Düsseldorf as an "urban dance battle event." Funkin'Stylez introduced their voguing category in 2008, but it really caught on in 2010, and featured competitors like Javier Ninja. Javier had also started to compete in (and win) House Dance International's (HDI) vogue category. HDI was an annual New York City event organized in 2007 to showcase house music dance culture. By 2010, HDI had attracted top vogue judges such as the world-renowned Cesar Valentino, a vogue dancer since 1983.

Ballroom, and specifically the dance form of vogue, was embraced globally by the dance world. Dancers from Vogue Evolution and others who had made names for themselves outside the world of Ballroom were now being invited by dance studios to teach classes both nationally and internationally. Voguing, which had once been ridiculed in a 1990 episode of *The Fresh Prince of Bel-Air* as a dance "for people who wanna look cool but ain't really got no rhythm," was being seen as an art form.

The history of Ballroom has been one of family and community. . . . [B]allroom is revolutionary because it has accomplished the idea of inclusivity and love. . . . The idea of allowing folks to realize their true selves and live out loud is certainly revolutionary. . . . The talent that is possessed in Ballroom, all the while uniting as a community of family along with allies, allows us to get back to our roots and makes for a bright future.

—Arnold St. Laurent, Icon/2x Ballroom Hall of Fame, lead organizer of House Lives Matter (2024)

This increased awareness and acceptance was exemplified at the 2010 Whitney Biennial in New York, which hosted Rashaad Newsome's multimedia performance, *FIVE*. It featured the voice of Kevin Jz Prodigy, a Ballroom commentator, music producer, and singer from Philadelphia, who would come to, in part, define the decade. The performance included voguers Prince Miyake-Mugler, Omari Oricci, and Dashaun Basquiat in performance sequences based on the five elements of vogue femme: hand performance, spin and dips, catwalk, duckwalks, and floor performance. The sounds of Ballroom—Kevin's voice and Mike Q's DJing—were mixed with the operatic vocals of baritone Stefanos Koroneos and live musicians. The performance sequences were later restaged in Hong Kong, at the Museum of Modern Art in San Francisco, and elsewhere. Newsome also integrated elements of the Ballroom scene in his studio work.

Television producers started to cast Ballroom performers, often in dramatic roles. Trace Lysette, a founder of the House of Gorgeous Gucci and a ball walker, had made her name in the House of Mizrahi as a legend in the category. In 2014 she was cast to play the yoga teacher, Shea, on the Amazon series *Transparent*. While Trace had been on television before, notably in a 2013 episode of *Law & Order: Special Victims Unit*, *Transparent* marked her coming out as a trans woman. She played the role of Shea in twelve episodes. Transparent also featured Ballroom in its opening credits, including a shot of Crystal LaBeija and a clip from Frank Simon's 1968 film *The Queen*, a groundbreaking documentary of the 1967 New York Miss All-America Camp Beauty Pageant.

In 2016, Amiyah Scott from the Haus of Maison Margiela, who had also made her name in the category of Face while in the House of Mizrahi, began appearing on the Fox series *Star*. Between 2016 and 2019, her character, Cotton, appeared in twenty-eight episodes.

The music world also joined the Ballroom party. Fresh off *America's Best Dance Crew*, Leiomy appeared in Willow Smith's 2010 debut music video "Whip My Hair." Swedish duo Icona Pop's music video for "All Night" (2013) was filmed at a staged ball and included Leiomy Maldonado and House of Xtravaganza members Hector, Jose, and Gisele.

Iconic Overall Mother Exotic Miyake-Mugler embodies Black beauty and Ballroom elegance, representing the pinnacle of achievement and influence in the contemporary Ballroom scene.

GET INVOLVED. BE INFORMED. STAY CONNEC

The author's son Nyno Pressley Du'Mure-Versailles, a renowned Old Way voguer who was part of the Houses of Jourdan, Garcon, and Milan, and later founded the House of Du'Mure Versailles, is captured here at the NY Awards Ball 2014.

British singer and dancer FKA Twigs enlisted the London-based Swedish dancer Benjamin Milan to choreograph her 2015 "Glass & Patron" music video, where she vogued, flanked by Alex Miyake-Mugler, Jamel Prodigy, and Javier Ninja.

Rihanna went a step further, casting Dashaun Basquiat and Baby Hurricane West in her *Anti World Tour* in 2016, where she joined them in a hand-and-arms performance breakdown. This wasn't Rihanna's first connection to Ballroom; in 2014, the singer and her longtime hairstylist, Yusef Williams, Father of the House of Miyake-Mugler, attended Mugler's Porcelain Ball.

The Ballroom community's connection to pop culture grew as it moved into the politics of visibility. In an attempt to be seen—and seen as legitimate—the community had to reach past its unique context to a wider world. Evidence of the massive expansion in the early decades of the twenty-first century, Steffie Mizrahi and Lasseindra Ninja established the foundations of a Ballroom scene in Paris. Koppi Mizrahi did similar work in Tokyo, where there had been a small voguing scene since the 1990s. Koppi began to host balls with her House son, Kinshasa Mizrahi, injecting the culture and context of Ballroom. The same thing was happening around the world, with access fueling expansion, and that global interest causing the scene to get bigger and stronger in American cities like Chicago, where it had long been established.

This expansion brought with it questions and conflict about corporate entities tapping into and adopting the cultural phenomenon of a marginalized group. Would Ballroom be reduced to a trend? What did it mean for a straight, white, cisgender pop star to temporarily surround themselves with a scene that was church and an ethos for the Black trans women who created it, and embrace an art form while often ignoring or distancing themselves from its roots? Would what was benefiting the few somehow diminish the wider community, which was still battling new HIV infections, anti-LGBTQ+ legislation, and the murder of Black and Latina trans women?

While there were—and are—no easy answers, Ballroom, as always, stepped up to care for its own. Martha Chono-Helsley,

Seven King, a Black trans filmmaker and Ballroom scene member, whose storytelling bridges underground LGBTQ+ culture with independent cinema through his documentary work.

Seven King's Eden's Garden *follows five Black and Latinx trans men, documenting their friendship and daily lives through intimate portraits celebrating trans masculine community and joy.*

The Equinox 2019 Pride campaign, Life's a Ball, was celebrated in this House Lives Matter calendar that showcased Ballroom royalty.

who was at the time the executive director of REACH LA (a group whose mission is "to engage, empower, and celebrate LGBTQIA+ people of color and their communities"), hired me to organize the very first National House/Ball HIV Leadership Convening in 2011. This was the first time that leaders from across the community gathered to effect change from within the scene. Alongside public health officials, the group wrote a white paper that put forth a national agenda addressing the health disparities affecting the Ballroom community nationwide.

As part of the event, Martha decided to replicate Ballstar Weekend with Ballstar Weekend Los Angeles, honoring the pioneers who helped create and organize the Los Angeles Ballroom scene. It was part of a larger event that included the national convening, a Legends Lunch, and REACH LA's Ovahness Ball, which was the West Coast's largest ball at the time. There was a second convening the following year.

The day after Donald Trump was elected president in 2016, House Lives Matter, a community organizing and mobilizing initiative created for and by the House/Ballroom community, was founded. In the years that followed, three things became clear: Ballroom is a radical pedagogy; Ballroom as a form of televised entertainment has a conflicted and complicated relationship to celebrity; and Ballroom is a global community.

At New York's 2014 Awards Ball, Stage 48: Legendary commentator MC Debra and Iconic Mother Simone Prada Maison Margiela shared a moment, their distinctive styles influencing new generations of Ballroom MCs and fashion icons.

At the Miyake-Mugler Ball in 2015, Lola Mizrahi claimed the Grand Prize in the Porcelain Beauty category, epitomizing the height of grace and refinement in Ballroom competition.

Esteemed figures from the Ballroom community served as judges at the prestigious Awards Ball in 2016, their iconic status adding further importance to the event.

Ballroom as Revolutionary Hope

Jennifer Legend, a celebrated femme queen renowned for her stunning Face category performances, left an indelible mark on the Ballroom scene before her untimely passing. Her legacy continues to inspire new generations.

On June 18, 2024, I collaborated with Union Theological Seminary to present a full-day event that was both a historical survey of the House/Ball community and an urgent call to action. Ballroom Has Something to Say: An Ode to Black Gay and Queer Men seamlessly blended lecture and performance. It served as a dual celebration, honoring both Juneteenth and LGBTQ+ Pride—two observances that intersect powerfully in the month of June.

The event posed three fundamental questions about the nature of performance.

1. What is it?
2. Does it have a politics?
3. Does it have a theology?

These questions enabled us to delve deep into the essence of Ballroom culture, exploring its artistic, political, and spiritual dimensions.

However, just after midnight, the joy and intellectual stimulation of our celebration were abruptly shattered. The presenters had just finished dinner at Toast restaurant in Harlem and were standing outside. Two Black men threatened violence, attempting to forcibly remove our group of Black gay men from the block. This sudden confrontation with hatred left us shaken and astounded.

We came to a staggering realization: this was not an isolated event. It was a stark reminder of the persistent discrimination and violence our community continues to face.

The moment carried a profound historical weight. It echoed events from sixty-one years ago when Black and white students protested segregation laws at a Woolworth's lunch counter in Mississippi; they were forcibly removed amid chants of "You don't belong here." It also brought to mind a more recent tragedy: the murder of O'Shae Sibley, a young Black gay man and leader in the House/Ball community, who was murdered at a Brooklyn gas station a year earlier for voguing to Beyoncé music playing from his car.

O'Shae's death became a watershed moment, sending shockwaves across New York City, the country, and far beyond. Beyoncé herself paid tribute, flashing "RIP" in honor of O'Shae at

What one does realize is that when you try to stand up and look the world in the face, like you had a right to be here, when you do that, without knowing this is the result of it—you have attacked the entire power structure of the western world.

—James Baldwin, from a speech in London (1968)

Alvernian Rafeek Prestige Du'Mure Versailles stands as a pioneering architect of the Philadelphia Ballroom scene, shaping its unique culture and community.

a *Renaissance* concert. In response to this violent tragedy, our community united in grief and anger. In New York, we organized a protest march at the site of his murder in Midwood, Brooklyn. There were coordinated protests in Miami, Toronto, and Los Angeles.

I vividly recall one of the lead organizers beginning the march with a powerful call-and-response chant: "Voguing is not a crime." The crowd echoed her words: "It is our duty to fight for our freedom. It is our duty to win. We must love and support one another. We have nothing to lose but our chains."

This moment of collective resistance also evoked painful personal memories. I thought of my kinship gay son, Joseph Jefferson, who died by suicide in 2010. His final Facebook post hauntingly captured the weight of living authentically in a hostile world: "I could not bear the burden of living as a gay man of color in a world grown cold and hateful towards those of us who live and love differently than the so-called mainstream."

Such interconnected moments of violence, resistance, and loss underscore the ongoing struggles faced by the Ballroom community. Yet they also highlight the community's resilience, its ability to transform pain into power, and its unwavering commitment to creating spaces of freedom and expression in the face of adversity. This capacity to find joy amid sorrow, to build community in the face of alienation, is the very essence of Ballroom's revolutionary hope.

Its ability to create spaces of freedom and expression in a world that often denies these basic rights to marginalized communities, along with its flamboyant performances and fierce competitions, fuels its revolutionary nature. In these ways, Ballroom poses an inherent challenge to social norms and power structures.

BALLROOM AS COMMUNITY ORGANIZING

Ballroom extends beyond the performance aspects that so many have become familiar with. The House/Ball community has long been engaged in community organizing. Jonovia Chase Lanvin (one of the executive producers of the 2014 documentary *I'm Your Venus* about the murder of Venus Xtravaganza, and colead of House Lives Matter's National Leadership Convening) envisions a future in which Ballroom empowers Black trans women, strengthens community ties, influences legislation, and reclaims misrepresented narratives in mainstream media.

Numerous initiatives demonstrate how Ballroom culture extends its influence beyond the dance floor, shaping narratives, policies, and spaces in the broader world. Among them are ArtsEverywhere's Ballroom Freedom School, an online forum of text-based education, with essays, interviews, and analyses related to Ballroom culture.

OTA stands for Open to All. It's a weekly mini-ball series at Brooklyn nightclub 3 Dollar Bill where Ballroom culture is nurtured and celebrated, offering embodied performance and spatial learning.

The Venus Pellagatti Xtravaganza House is a multifaceted initiative involving landmark designation for cultural and historical sites (including Venus Xtravaganza's house in Jersey City, New Jersey), posthumous name change, and a film, demonstrating art as a form of community and political organizing.

Cats: "The Jellicle Ball" is a reimagining of the Broadway show centered on the House/Ball community. It ran to great acclaim in New York City over the summer of 2024, showcasing storytelling as a form of cultural education.

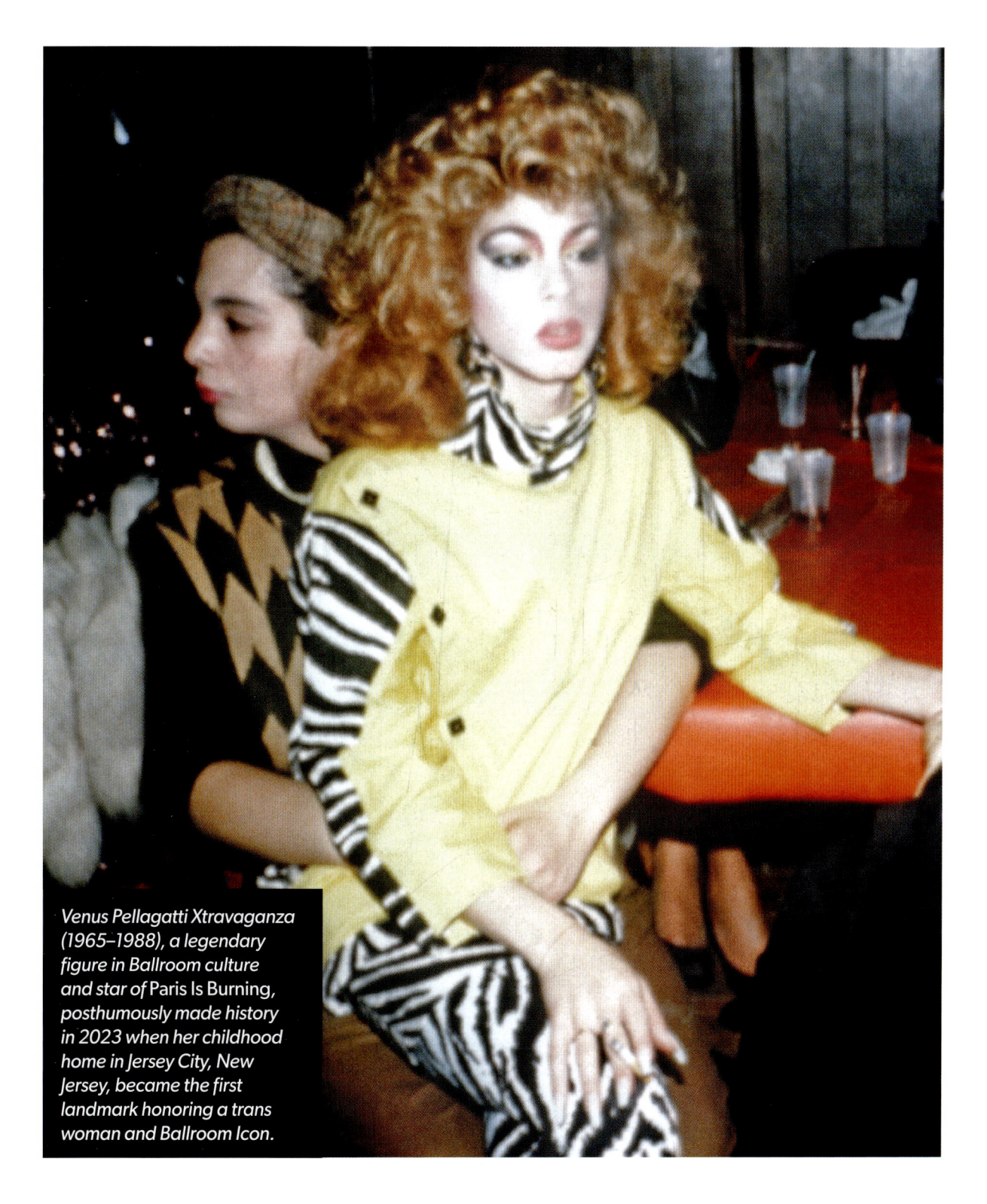

Venus Pellagatti Xtravaganza (1965–1988), a legendary figure in Ballroom culture and star of Paris Is Burning, *posthumously made history in 2023 when her childhood home in Jersey City, New Jersey, became the first landmark honoring a trans woman and Ballroom Icon.*

The Forever Ball Part 1 in 2024 marks Ballroom's expansion into Ghana, illustrating the culture's global journey and its role in fostering new spaces of self-expression and liberation across continents.

BALLROOM'S GLOBAL IMPACT

The impact of Ballroom is not confined to the United States. Its presence in places like Vietnam, Brazil, Mexico, Ghana, Jamaica, and even Russia speaks to its power as a global movement. In places where democracy is fragile and anti-LGBTQ+ legislation is on the rise, Ballroom is a beacon of hope, allowing people to dream beyond the limitations of their governments and resist oppression.

In a conversation with Marlon Bailey (an associate professor at Arizona State University and author of *Butch Queens Up in Pumps*) he highlighted Ballroom's role not just as a subculture, but as a vital force shaping the future of Black cultures worldwide. He said, "As Ballroom culture expands rapidly in the US and throughout the globe, these communities will continue to teach us how to care for each other and, ultimately, how to live despite the perilous times that we face. In essence, Ballroom culture is the past, present, and future of Black cultures globally."

BALLROOM AS REVOLUTIONARY HOPE

Ballroom continues to thrive and expand globally, conveying a hope that people can dream beyond limitations, demand equity for all citizens, and envision a global beloved community. It sits at the intersection of spiritual formation, radical inclusivity, beloved community, and the Black Church tradition.

The future of Ballroom lies in its continued ability to serve as a space for radical inclusivity, community building, and resistance against oppression. It embodies what Dr. Cornel West refers to as "paideia"—a kind of education that encourages active learning and a synthesis of different types of knowledge. Ballroom culture wrestles with the very conditions of life and death, reflecting on

its collective self while privileging joy as its primary means of political organization.

Robert Sember, assistant professor at the New School Eugene Lang College of Liberal Arts, and member of Ultra-red, an international art collective, recently shared these thoughts with me: "Ballroom's exuberant, joyful, brilliantly innovative, and, yes, sometimes damaging clashes have spoken into the bodies and spirits of millions around the world. Ballroom's call has established constituencies of fugitivity. This great escape from the slow deaths of normativity is possible because we realize we are not alone in our becoming, we are not alone at the edge of who we have been told we ought to be. . . . Ballroom endures because so many commit to the endless conversation, to the radicality that lives in the shaded, less-glamorous work of mutuality, care, grief, equity, and non-covetous love. This is the edge."

LEGENDARY/ICONIC

Ballroom culture stands as a testament to the power of community, creativity, and resilience in the face of systemic oppression. Born from the margins of society, it has evolved into a global movement that challenges social norms, celebrates diversity, and creates spaces of radical inclusivity. More than just a performance art, Ballroom embodies a revolutionary spirit that allows individuals to reimagine themselves, forge chosen families, and resist the constraints of a world that often seeks to silence them.

Ballroom is a movement that continues to push boundaries, challenge conventions, and create spaces of freedom and expression for marginalized communities worldwide.

As we look to the future, Ballroom remains a powerful force for change, a testament to the resilience of the human spirit, and a beacon of hope for those seeking to create a more just and inclusive world. Its journey from the margins to the global stage is a reminder that revolution often begins in the most unexpected places, with those who dare to imagine a different world and have the courage to bring that vision to life.

At the Ovahness Ball, Fe Garcon, the legendary Mother of the Los Angeles chapter of the House of Comme des Garcons, showcased her mastery in the Gothic Runway category, blending avant-garde fashion with Ballroom artistry.

Reflecting the global Black Lives Matter movement, the organizations Black Pride Netherlands and Black Queer and Trans Resistance Netherlands held a protest in Amsterdam on July 25, 2020.

At the Black Pride Ball Netherlands in Amsterdam, on June 26, 2021, Wicked Garcon from the Paris chapter of the House of Garcon took home the grand prize in the All American Runway category.

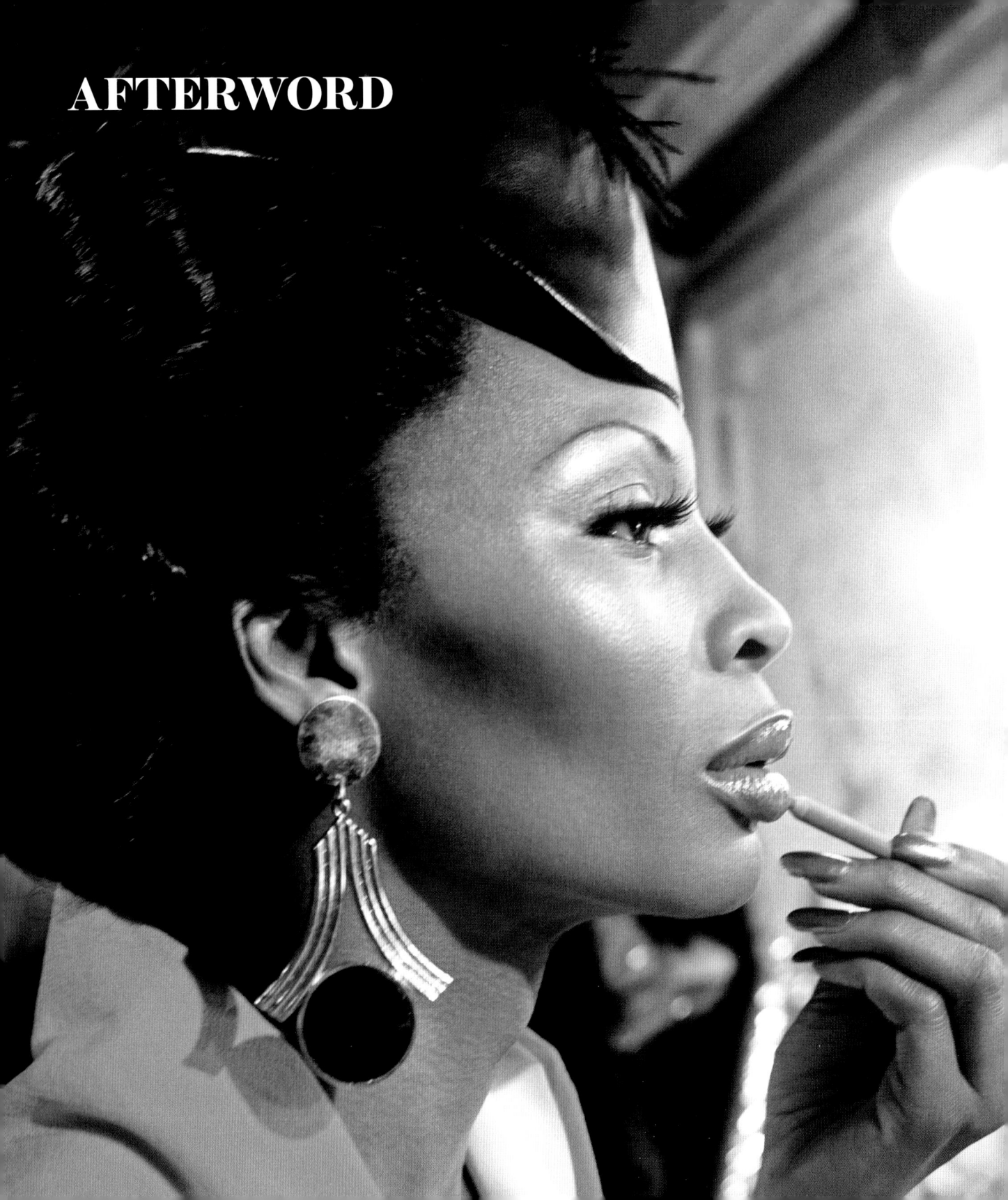

AFTERWORD

It is a great honor to write this. To document history is profound, but to document history to bring enlightenment, freedom, visibility, and empowerment to an entire community is how we build a society where all can coexist—where differences become education instead of reasons for erasure.

It was Thanksgiving of 2001 when Michael Roberson met with me at my chosen and proven father's house. He was dating my chosen and proven brother at the time. It was after dinner, as he pulled me aside and offered me the position as Mother of the House of Maasai, that I saw a man determined to help heal his community. It was not only about having a Ballroom House but also about connecting Ballroom to support health and self-value and providing familiar spaces where employment met the needs of the individuals in Ballroom who already faced trauma from lived experiences.

His proposal was magnificent. I felt seen and valued. However, I was very hesitant because at that time my focus was on gaining legal status in the United States, and I feared sharing that with anyone. I felt that because of new immigration laws, the best course of action for me was to stay hidden. I would carry this feeling for the next fourteen years, but it was my dear brother Michael Roberson who provided the space for me to feel of value and worth, and showcased how he was and is also a mentor, motivator, brand ambassador (even when I did not know I was a brand), friend, and most importantly, a brother. I refer to him as my personal advocate to the world, but in Ballroom he is my butch queen, the cis male–identified figure who would constantly put me on a pedestal, providing wind-beneath-my-wings support in times of need, empowering me to further my dreams and ambitions, and being my champion in a highly competitive scene where erasure comes if one is not constantly on display. He did this with respect for my identity and considered my life journey and how the world around me would affect me.

Michael is an advocate who not only stands up and out but is also extremely intentional in telling our history of Ballroom. Over the past decade he has catapulted the trans woman to a space of value and worth by delivering a truth in history that continues to

not only empower that community but enlighten those within the community who do not understand their trans siblings, while delivering an unapologetic truth of the sacrifice of the trans woman to Black history and culture. He has put the trans woman into the conversation as a part of the conversation about women, and has unapologetically brought the conversation about the Black trans woman and Ballroom into the theological and religious space.

This body of work speaks volumes to the inclusion of the Black trans woman in the struggle of Black women as nurturers and bearers of the fruit that is the uplifting of the Black man—the woman who nurtures and develops a space called Ballroom, which embodies a movement of freedom. It is a movement for those who do not identify with social gender norms, but are very much a part of society where mannerisms and vocabulary are stolen and actual human lives are cut short.

—Dominique Jackson

Actress, author, model, and activist
Known for her leading role as Elektra Abundance on the television series Pose, *Bloody Mary in American Horror Stories, and Ms. World in* American God

Dominique Jackson, renowned for her portrayal of Elektra Abundance in the groundbreaking series Pose, *brings the golden age of Ballroom to life on-screen, embodying the fierce leadership and glamour of a House Mother.*

ACKNOWLEDGMENTS

This is one of those moments that come very rarely in a lifetime, if we are lucky, if we are blessed. I consider myself among those who have been abundantly blessed. Being a vessel for this book's manifestation is one of the blessings that has repeatedly filled my cup with gratitude and deep, resounding appreciation.

There have been so many people who have touched my life, expanded my consciousness, and served as thought provokers, dialogue partners, teachers, mentors, and spiritual warriors. My mother, Mary Elizabeth Alston, who passed away some seventeen years ago, has always been and continues to be my everything. My father, Thomas Denson, I now realize did the very best he could. To my sisters, nephews, and nieces, whose love poured into me growing up in Camden, New Jersey, I say thank you. And to my aunties, my momma's sister friends, who knew it always took a village to raise a child—in particular, a Black gay boy child—I say thank you.

Having worked in public health and research for more than thirty years, I extend my gratitude to all those brilliant people who mentored me. I especially thank those Black gay men who, in the face of a devastating epidemic (HIV/AIDS), continued to fight when the world was telling us we were not worth fighting for.

To the brilliant intellectuals who helped shape me with new thoughts and visions, with a deeper sense of both communal responsibility and the democratic ethical principles of living in one's truth (Robert Sember, Edgar Rivera Colón, Martha Chono-Helsley, Arbert Santana, Odu Adamu, Kirk Myers, LaRon Nelson, and Michael Leon), I say thank you.

I express my gratitude to all those at Union Theological Seminary who provided me with the theological understanding and language to codify the very underpinnings of this book (Bishop Dr. Yvette Flunder, Dr. James Cone, Dr. Charlene Sinclair, Dr. Eboni Marshall Turman, Dr. Gary Dorrien, Anika Gibbons, Dr. Sarah Azaransky, and Dr. Cornel West).

To the leaders of organizations I've collaborated with over the past twenty years, whose support and love gave me the foundation and strength to do the work my soul said it must do (including Dont Rhine/ Ultra-red, Barry Esson and Bryony McIntyre/ARIKA, Shawn Van Sluys/

Musagetes, Dr. Jennifer Lee/House Lives Matter, Alessandra Pomarico/ Free Home University, Rodney McKenzie Jr./Fetzer Institute, Dr. Jeffrey Birnbaum/HEAT, Dr. Tara Jae/Youth Seen, Esther Morales/Clean Energy Leadership Institute, Aaron Paige/ArtsWestchester, and Gabriel Florenz/Pioneer Works, City Lore), I say thank you. To collaborators such as Lisa Shufro, Noah Levy, Silas Howard, Jordan MacArthur, Mike Stafford, Lee Soulja, Mike Haynes Ebony, Tommy Dee Murphy, Andre Paul Ebony, Bernie Ebony, Twiggy Pucci Garçon, and Jonovia Chase Lanvin (the last two also happen to be my children), I say thank you. We have made some magic happen over the years.

To my sister in spirit, the Icon Ballroom Hall of Famer, actress/model Miss Dominique Jackson, thank you so very much for writing the Afterword, and for being by my side for more than twenty-five years.

To the team who helped shape this book, Chris Navratil, Susan Knopf, Tim Palin, Mikelle Street, and Ada Zhang, who extended the invitation to embark on this writing journey, I say thank you. A special shout-out to Randall Lotowycz, Jenna McBride, Frances Soo Ping Chow, and Amber Morris along with the creative, production, and sales and marketing teams at Running Press/Hachette Book Group, I say thank you. To all the incredibly generous photographers whose works contribute so greatly and deeply to this book, I say thank you. To those who are my predecessors, those who came before with their own Ballroom books (Chantal Regnault, Gerard Gaskin, Marlon Bailey, and Ricky Tucker), I say thank you.

To all the Ballroom Ancestors who made a way out of no way, and to the Pioneers, Icons, Legends, Statements, and Stars around the globe whose bodies continue to make magic happen, whose efforts continue to create more spaces of freedom, and whose desires continue to create a bountifully beautiful legacy, I say thank you.

Lastly, to my Ballroom children, the many I have been blessed to call my own, I say thank you. You have made my life that much more meaningful, that much sweeter, that much fuller. You are and continue to be the gifts that keep on giving.

I dedicate this book to two of my sons, Joseph Jefferson Blahnik and Nyno Pressley Du'Mure-Versailles, who tragically took their own lives, and made me realize how necessary it is to say "I love you" every time you get a chance to say it.

ABOUT THE AUTHOR

MICHAEL ROBERSON is a theologian, public health practitioner, and pioneering voice in the House/Ball Community. A Senior Scholar at the Center for Race, Religion and Economic Democracy and professor at both the New School and Union Theological Seminary, he champions Black and Latinx LGBTQ+ advocacy through the Ballroom Freedom School. His expertise in Ballroom culture extends to his role as cultural consultant for the FX series *Pose*.

ABOUT THE CONTRIBUTING PHOTOGRAPHERS

ANJA MATTHES
www.anjamatthes.com | IG: @anjamatthes

Anja Matthes is a New York City–based documentary photographer who has spent more than twelve years capturing the Kiki Ballroom scene through her ongoing project, The House of Bangy Cunt. Her work highlights the resilience, creativity, and chosen family bonds within this vital space for LGBTQ+ youth of color.

CHANTAL REGNAULT
IG: @chantalregnaultphoto

Chantal Regnault, born in France, has lived in the United States since 1970. She was a doctoral candidate in French Literature at New York University before studying photography at the International Center for Photography and the School of Visual Arts in New York. From the late 1970s to the early 1990s, her work was mostly focused on marginal cultures flourishing in New York at the time, including the Ballroom scene. In 1993, Chantal established residency in Port-au-Prince, and Haiti became her primary source of photographic inspiration for the next twenty years.

Regnault's work both in New York and Haiti has been published in numerous newspapers and magazines including the *New York Times*, *Village Voice*, *Liberation*, *Newsweek*, *Vanity Fair*, and *Aperture*. She has exhibited in the United States, Europe, and Haiti and is represented in collections at the Fowler Museum at UCLA; the William Benton Museum of Art at the University of Connecticut; the Museum für Kunst und Geschichte in Fribourg, Switzerland; and La Maison Européenne de la Photographie in Paris. Her book *Voguing and the House Ballroom Scene of New York City 1989-92* was published by Soul Jazz Books, London (2011).

DUCHESS LA WONG
Fashionista, Founding House Mother, with a Ballroom résumé that just keeps on growing, Geraldine Baker (Duchess La Wong, House of Wong) is one of the originals. Born in New York City in 1951, she discovered the House/Ballroom culture on a night in 1967 when she was hanging out in front of Andre's Bar in New York City. A passenger stepped out of a car wearing a beautiful, ruffled gown and paraded around the street in it. Duchess asked where they were going and was told that they were headed to a ball at the Hotel Diplomat, which sounded so extravagant. Duchess was told she would be invited the next time.

In 1968, Duchess went to her first Ballroom ball, which was held at the Karate Club on 123rd Street in New York City's Harlem neighborhood. The event was hosted by Jerome Fraiser, and Duchess walked a fashion category and won the Grand Prize. In subsequent balls, she walked various categories, including Foot and Eyewear, Leather vs. Suede, and Silk vs. Linen. She paid particular attention to detail on her Ballroom gowns and created special effects with beading. Duchess went on to compete and win in the Best Dressed category.

Pier Wong became her Mother when she joined the House of Wong. The last ball that Duchess walked was the Ballroom Throwbacks TV Ball in February of 2019, where she ended up in the last battle against a House of Tisci contestant. Duchess won the Grand Prize trophy. For more than five decades, there is no other who has remained relevant and current to this day.

EBONI BONEÉ COLEMAN (EB)
www.ebpixs.com | IG: @ebpixs3

Eboni Boneé Coleman (EB) is a multimedia artist, owner of EB Pixs, and cofounder of Black Pride Colorado. She is a creative who focuses on contextualizing the lived experiences of her community as a Black queer woman. With a keen eye for the subtle details of her environment, EB's work has been featured in various publications locally and nationally, including *Blavity, Westword*, the *Denver Post, Out Front Magazine, Colorado Homes & Lifestyles*, Denver Center for the Performing Arts, and 9 News.

A native of Denver, EB's distinctive eye is influenced by her background as a performer. With the ability to see the hidden patterns and make connections for a larger story, EB has the innate sense to see the impact of the photo before it happens, resulting in powerful captures of what is now our communal history.

GERARD H. GASKIN
www.gerardhgaskinphoto.com

Gerard H. Gaskin, a native of Trinidad and Tobago, is a freelance photographer whose work is widely published in the United States and abroad, including in the *New York Times, Newsday, Politiken, Black Enterprise, Teen People, Caribbean Beat,* and *Guardian*. His book *Legendary: Inside the House and Ballroom Scene* was published in 2013 from Duke University Press.

Gaskin's photographs have been featured in solo and group exhibitions across the country and abroad including at the Nasher Museum of Art at Duke University, the African American Museum in Philadelphia, the Brooklyn Museum, and CM2A in Madrid. His work is represented in the permanent collections at the Philadelphia Museum of Art, the National Museum of African American History and Culture in Washington, DC, and the Museum of the City of New York.

Gaskin has won many important awards, grants, and residences, such as the CDS/Honickman First Book Prize (2012), the Center for Photography at Woodstock Artist-in-Residence program (2011), and Light Work's Artist-in-Residence (2010). He was also included in the "Gordon Parks 90" that brought together ninety of the top Black photographers in the United States to celebrate Gordon Parks's ninetieth birthday.

GINA LAMB
www.flickr.com/photos/195973285@N07/albums

Gina Lamb is a Los Angeles artist-activist-teacher who has worked collaboratively with youth and nonprofit groups for the past thirty-five years to foster community storytelling through collaborative digital media production. These projects explore race, class, gender identity, sexual orientation, and indigenous and immigrant issues, and have been presented nationally in museums and galleries, as well as on broadcast television.

Lamb teaches production and theory in the Media Studies Department at Pitzer College, developing Media Arts for Social Justice curriculum that guides students to utilize their skills and resources to create collaborative media projects with local community organizations.

Honors include a National Endowment for the Arts fellowship, an Anonymous Was A Woman (AWAW) award, and grants from the Rockefeller Foundation, California Humanities, City of Los Angeles Department of Cultural Affairs, and California Arts Council.

LUNA LUIS ORTIZ
IG: @lunalens

Luna Luis Ortiz began his photography career at fourteen after an HIV diagnosis. In the late 1980s, Ortiz actively participated in the New York Ballroom voguing scene, where his artistic talents, particularly in photography, flourished.

An HIV awareness advocate, he has received recognition from New York City mayors, and he received the Distinguished Service Award from the State of New York for his AIDS awareness efforts. Ortiz has been invited to share his life and art at prestigious institutions including New York University, Cornell University, Penn State University, and Yale University. His work has been shown at notable museums such as the Jersey City Museum, Boston Center for the Arts, and Eternity Gallery in Paris, and in New York at the Whitney Museum of American Art, Queens Museum, Museum of the City of New York, and American Folk Art Museum.

At GMHC, Ortiz contributes to social marketing campaigns and organizes youth workshops and events. He hosts Kiki balls, conferences, and health fairs that empower young individuals of diverse backgrounds in the Ballroom community, and he is a guiding force within the House of Khan.

ZELDA FITZGERALD
IG: @for_all_queens

Zelda Fitzgerald is a multidisciplinary artist recognized as the first voice of the Dutch Ballroom and is part of the first generation of European voices.

She cofounded the Belgium-based collective FOR ALL QUEENS!, co-initiated the Black Pride Ball in the Netherlands, and is a founding member of the Ghana-based Free Forever Collective. Currently, she takes on the prestigious role of the first European Overseer for the Xclusive House of Lanvin.

Book coproduced by:
Christopher Navratil
Susan Knopf, Scout Books & Media Inc

Special thanks to Beth Adelman and Leah Tracosas Jenness

Running Press
Hachette Book Group
1290 Avenue of the Americas, New York, NY 10104
www.runningpress.com
@Running_Press

First Edition: June 2025

Published by Running Press, an imprint of Hachette Book Group, Inc.
The Running Press name and logo are trademarks of Hachette Book Group, Inc.

The Hachette Speakers Bureau provides a wide range of authors for speaking events. To find out more, go to www.hachettespeakersbureau.com or email HachetteSpeakers@hbgusa.com.

Running Press books may be purchased in bulk for business, educational, or promotional use. For more information, please contact your local bookseller or the Hachette Book Group Special Markets Department at Special.Markets@hbgusa.com.

The publisher is not responsible for websites (or their content) that are not owned by the publisher.

Print book cover and interior design by Tim Palin Creative

Library of Congress Control Number: 2024950269

ISBNs: 978-0-7624-8908-4 (hardcover), 978-0-7624-8909-1 (ebook)

Printed in China

TLF

10 9 8 7 6 5 4 3 2 1

PHOTO CREDITS: **Andrew Ratto**: 112*; **Anja Matthes**: 40, 60, 176, 178, 180, 182, 184, 186; **Beyond My Ken**: 119*; **Chantal Regnault**: 16, 133, 134, 140, 142, 144, 146, 148, 164; **Chicago History Museum**: 77 (top), 79; **Darrell Nance**: 4*; **David Shankbone**: 56*; **Duchess La Wong**: 120; **Eboni Boneé Coleman**: ii, 23, 30, 72, 74, 170, 172; **FOR ALL QUEENS!**: 28, 161, 210, 214, 215; **Gerard H. Gaskin**: iv, ix, 2, 6, 12, 24, 26, 31, 32, 38, 52, 54, 55, 58, 66, 68, 139, 150, 156, 157, 158, 174, 190, 192, 199, 200, 202, 204, 206, 226; **Library of Congress**: 5, 72, 77 (bottom), 78 (top), 80, 83, 84, 85, 86, 87, 90, 91, 93, 96, 101, 111, 116, 137; **Luna Luis Ortiz**: 11, 15, 34, 141, 152, 154; **Michael Roberson**: 159; **Pax Ahimsa Gethen**: 19*; **Photofest**: xv, 8, 42, 44, 46, 48, 50, 51, 64, 65, 86, 103, 106, 109, 123, 162, 166, 169, 209, 216, 219, 220; **Public Domain**: 82, 98, 104; **Rachel Miniman**: 213; **Ralph_PH**: 70*; **RCF/Everett Collection**: 57; **Rhododentrites**: 114*, 118*; **Ryan Lash**: vi; **Seven King**: 194–195; **Smithsonian**: 90, 91; **Susan Nagib**: xii; **The Tranarchist**: xi*; **Tre Milan Maison Margiela**: ix (top). *Creative Commons license information: https://creativecommons.org/licenses/by-sa/4.0/